MAN·AS·ART NEW GUINEA

PHOTOGRAPHS BY MALCOLM KIRK

Essay by Andrew Strathern

CHRONICLE BOOKS

SAN FRANCISCO

Printed in Hong Kong.

Library of Congress Cataloging-in-Publication Data
Kirk, Malcolm.
 Man as art : New Guinea / photographs by Malcolm Kirk :
essay by Andrew Strathern.
 p. cm.
 Originally published: New York : Viking Press, 1981.
 ISBN 0-8118-0478-X (softcover)
 1. Body-marking—Papua New Guinea. 2. Masks—Papua New
Guinea. 3. Portraits—Papua New Guinea. 4. Papua New
Guinea—Social life and customs. I. Strathern, Andrew. II. Title.
GN671.N5K57 1993
391´.6—dc20 93-3300
 CIP

Book and cover design: David Bullen
Cover photograph: Malcolm Kirk

Distributed in Canada by
Raincoast Books
112 East Third Avenue
Vancouver, B.C. V5T 1C8

10 9 8 7 6 5 4 3 2 1

Chronicle Books
275 Fifth Street
San Francisco, California 94103

CONTENTS

ACKNOWLEDGMENTS

6 ·

Among the many people who helped make this book possible, I wish especially to express my gratitude to the following individuals and corporations: Omni Publications International, and in particular Robert Guccione and Kathy Keeton for their friendship and support; Polaroid Corporation, especially Adrian Van Dorpe, and to Pan American World Airways and Air Niugini; the people of Papua New Guinea, among whom I have spent the most memorable moments of my life; and Warren and Joy Dutton, David and Helen Eastburn, Dr. Stephen Frankel, Laurence Goldman, Mary LeCroy, Richard Longley, Roy and Margaret Mackay, Tara Monahan, Michael and Linda O'Hanlon, Dr. Daniel Shaw, Professor Andrew Strathern, and Dr. Clements Voorhoeve for assistance with photographing the faces and preparing the captions.

I photographed more fine masks than I could find space for in this book. Among the numerous individuals who gave of their time and helped me locate material are Dr. George Bankes, Jean-Paul Barbier, Ben and Marie Birillo, Serge Brignoni, Robert Burawoy, Lynda and Kevin Cunningham, Ronald and Hortense Clyne, Emile Deletaille, André Fourquet, Harry Franklin, Philip Goldman, Baudouin de Grunne, Philippe Guimiot, Dr. Dieter Heintze, Dr. Klaus Helfrich, Ben Heller, John Hewett, Dr. Christian Kaufmann, Jacques Kerchache, Dr. Friedrich Kussmaul, Dr. Hartmut Lang, Dr. Werner Meunsterberger, George Ortiz, Dr. George Park, Dr. Clara Pink-Wilpert, Charles Ratton, Alain Schoffel, Dr. Jim Specht, Dr. Waldemar Stöhr, Loed and Mia Van Bussel, Lucien Van De Velde, and several other collectors who wish to remain anonymous, I am grateful to them all.

My thanks also go to Tom and Nancy Tafuri, who are largely responsible for the book's design; to Arthur Ceppos, for suggesting the title; to Dee Ito and Marshall Arisman; to Tennyson Schad; and to Barbara Burn, Sophie McConnell, and Michael Shroyer, for the book's ultimate realization.

Finally, my love and admiration go to Bryce Birdsall, my partner, friend, helper, and wife.

M. K.

NOTES ON THE PHOTOGRAPHY

All the photographs in this book were taken with Nikon camera equipment, the most frequently used lens being the 55-mm Micro-Nikkor. Whenever possible, I used Kodachrome film, often in conjunction with an electronic flash unit, which provided me with sufficient depth of field and a satisfactory color saturation. The lighting technique could undergo further refinement, but it serves to emphasize the masklike quality of the human faces.

One invaluable piece of equipment I carried with me was a Polaroid sx-70 camera, which helped me establish a quick and friendly rapport with my subjects. I also used the instant pictures as a diary, noting down the individuals' names, villages, and tribes for correlation at a later date with my 35-mm transparencies. The quality and permanence of these photographs is remarkable.

All of the masks were photographed on Panatomic-x film, and the superb black-and-white prints were made by Don Stickles and Mike Levins.

M. K.

FOREWORD

by Malcolm Kirk

People seeing these pictures for the first time frequently exclaim, "What fabulous photographs!" Flattering though this is to my ego, I have to correct them by replying, "No, what fabulous images!" My own contribution has been simply to record what exists.

Self-decoration in New Guinea is such an extensive subject that this book barely skims the surface. Some of the designs illustrated here are traditional ones, others the product of individual idiosyncracy. The final selection, distilled from hundreds of images recorded over seven visits to the island between 1967 and 1980, is based purely on my personal taste.

Books carry a seal of authority to them, such is the tyranny of words and the printed page in our society. I make no claims for this work as a definitive study. When self-decoration is practiced by people as diverse and unfamiliar to us as those of Papua New Guinea, the manner in which we see them may be a far cry from the way they view themselves.

This is an aspect Professor Andrew Strathern explores in his introduction, and the result is an enlightening perspective from the other side. Strathern has spent considerable time with the people of two Highland societies, speaks their languages, and enjoys their confidence. He is also a respected anthropologist who has long been fascinated by their remarkable self-decoration. There are few individuals better suited from our society to provide an insight into theirs.

While Strathern is concerned with the significance of self-decoration as an element of social communication, I myself have always been intrigued by the mutation of the individual image into something less recognizably human. These are human faces, yet there is some other intangible presence reflected in them. Transformed by paint and plumage into masks, they hover on that mysterious border separating the familiar from the obscure. This metamorphosis is heightened when true masks are worn, as is the custom of some tribes, chiefly

those found in the coastal areas of the country. Infused with an unearthly presence of their own, they seem to be an affirmation of the natural and supernatural powers controlling man's destiny.

Whatever it is that motivates people to decorate their bodies, the fact is that the human form can become art, and may indeed have been mankind's original work of art,* stirring emotions similar to those we experience when confronted by any other art form. It is an appreciation shared by Wömndi, Strathern's informant, whose reaction to the sight of splendidly attired fellow-clansmen is "We look at them and we are pleased."

Ideally, I would have liked to present the views and reactions of a variety of people to these images, if only to demonstrate that there are several ways to examine the same topic. Practicality prevents this, but two viewpoints have already been focused on the subject: that of an anthropologist drawing upon methodical investigation and contemporary psychological theory, and that of two of the artists themselves. As the photographer, I would like to offer a few speculative thoughts of my own on costume in general.

Wrapping seems to be a universal custom, and it arouses a sense of curiosity and expectancy regarding the contents. The masquerade of the ordinary posing as the extraordinary bestows on it formidable illusionary powers. Supernatural power, for example, is contained in a shaman's magic bundle, which is often nothing more than bones or stones concealed by a different "skin." The power of a sorcerer's spell is wrapped up in the words and in the way the spell is delivered.

If costume was originally designed to replace the natural fur that once protected us against the elements, people must have quickly understood it had the potential to be more than this. By shrouding the human body, clothing disguises our exposed, vulnerable selves and elevates the ways we feel and respond. Costume instills a sense of potency in the wearer, and entices the viewer as well.

Through an expedient choice of dress, we feel more secure; we join a particular social class while simultaneously announcing our individuality within society at large. More important perhaps, our ability to change our appearance stimulates fresh emotions and behavior and lets us assume different, though temporary, personalities, satisfying a yearning for variety in life.

Costume therefore masks not only our bodies but also our inhibitions and raw natures. It liberates our imagination. In our fantasies, it fashions gods out of mortals. Comic-strip heroes such as Batman and Superman don cloaks that become wings of invincibility, while in real life suitably awesome garments can transform kings and clergy into God's representatives on earth. Someday mere men cocooned impersonally like silver robots will hurtle into the heavens as Earth's representatives to other planets.

Our faces themselves are constantly shifting masks that mirror varying moods of happi-

*The earliest known cave-art, located at La Ferrassi in France, was done around 25,000 B.C. Ocher-colored hematite was mined for use as body paint around 41,000 B.C. in what are now the Ngwenya Hills of northern Swaziland.

ness and sorrow, anger and fear, sincerity and deception, and our eyes become an outward reflection of the emotions within.

Unlike us, New Guinea people traditionally have had no access to artificial materials, which frequently are cold and impermeable. Instead, they utilize nature's living, porous tissues, such as woods, grasses, and feathers, which impart warmth and vitality to tribal art. They are also inspired by the powers of nature, particularly animals possessed of extraordinary strength or speed or beauty, creatures that have the freedom to soar or swim where man cannot follow.

It strikes me that of all the animals that have influenced mankind, we have felt the greatest affinity with birds. We envy and admire their elegance and freedom. In the flashing eyes and hooked beaks of birds of prey, we instinctively recognize ferocious strength. In the dazzling magnificence of birds of paradise, we perceive beauty that we desire for ourselves. In almost every human society we find art and myth linking man and bird: people with wings, people with falcons' heads, people attaching paint and plumage to their own bodies, just as the tribes in New Guinea do.

The tribespeople seem to accept self-decoration for what it is: a tradition handed down by their ancestors that is an elemental part of their lives. They feel no need to elaborate on it verbally, at least not with the kind of analytical detachment we value.

We, on the other hand, live in a society absorbed by academic debate and rationalization. Increasingly we seek to codify art as though we are uncomfortable with our intuitive appraisal of it. By emphasizing the objective evaluation of art, we begin to question our subjective responses to it; spontaneous appreciation is stifled in favor of calculated dissection. We lean on scholars and critics to interpret the works of artists in the mistaken belief that verbal articulateness is synonymous with visual sensibility.

Our obsessive desire to understand *why* is foiled only by the limitless depths of our imaginations. We may dream of acquiring the grace and power of birds, but we can only guess at the underlying causes. The answer is that there is no answer. In the end, we must be guided by intuition as well as by reason.

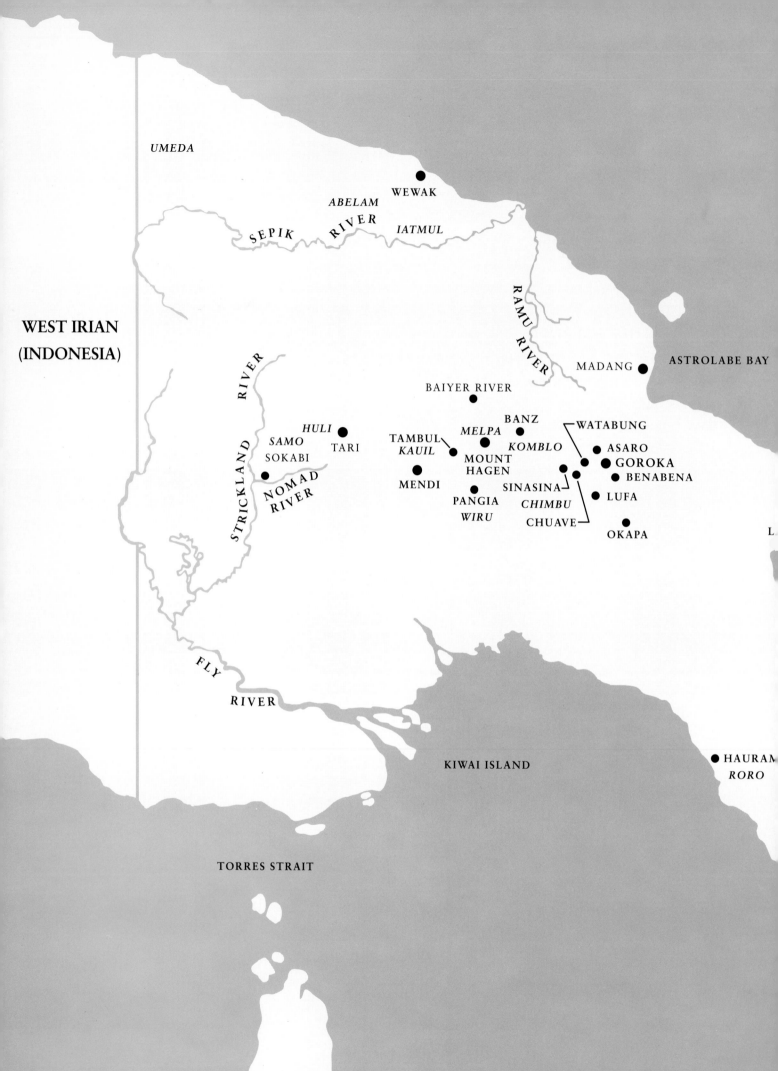

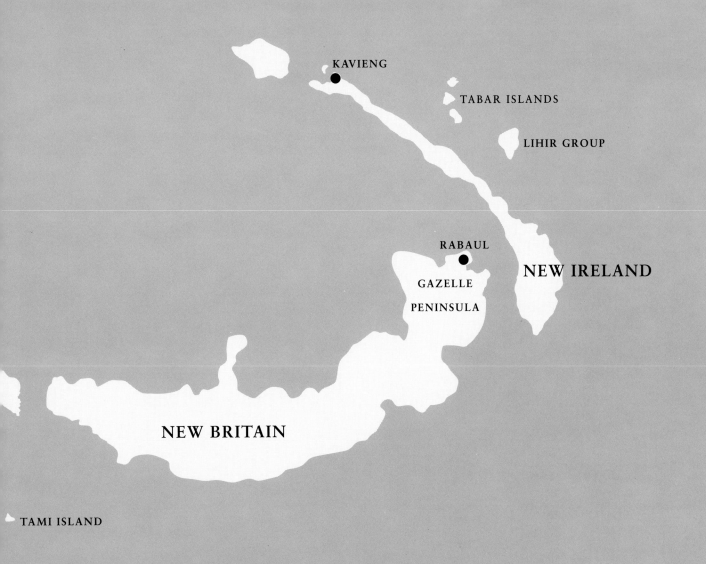

KAVIENG

TABAR ISLANDS

LIHIR GROUP

RABAUL

GAZELLE
PENINSULA

NEW IRELAND

NEW BRITAIN

TAMI ISLAND

ON GULF

PAPUA NEW GUINEA

DRESS, DECORATION, AND ART IN NEW GUINEA

by Andrew Strathern

An old debate in anthropology has to do with the origins of clothing. Was clothing adopted for reasons of shame (the "fig leaf" theory), for practical protection against the weather, or to enhance one's sexual attractiveness? Discussions of this kind can, of course, never be settled, partly because we have no direct evidence and partly because human behavior tends in any case to be more complicated than any such straightforward theories would suggest. Most probably, elements of all three factors have been involved. But modern studies suggest than an overall factor is of paramount importance: the dimension of social communication. What people wear, and what they do with and to their bodies in general, forms an important part of the flow of information—establishing, modifying, and commenting on major social categories, such as age, sex, and status, which are also defined in speech and in actions. Whatever the precise origins of clothing, then, they can be sought only within the general context of the development of social communication and of society itself. And a persistent feature of communication is the interplay between the assumption of group identity and the assertion that the person is nevertheless also an individual. Adornments and decoration in particular carry this "load" of sometimes contradictory meanings.

New Guinea is an excellent area of the world in which to examine this problem. Its numerous small-scale societies and language groups—previously connected by common patterns of culture-history and far-flung systems of regional trade and now welded together as members of the nation-state of Papua New Guinea—represent so many experiments in related cultural themes. Nowhere did these societies develop into centralized states or large hierarchical chiefdoms on the model of the Polynesian societies to their east in the Pacific Ocean. There were certainly hereditary chiefs in several cases, especially in coastal areas whose peoples perhaps originally migrated from the eastern Melanesian islands to the New

Guinea mainland some four thousand years ago. In the Central Highlands, however, discovered by European explorers only in the 1930s, we find a classic evolution of what is called the "big-man" type of leadership. In this, the leader is rarely more than first among equals, and although he may occasionally achieve almost despotic power, on the whole he has to face constant challenges of wealth, in speechmaking, and in influence over the labor of his domestic group and over a wider network of supporters. These societies are thus marked by an emphasis on relatively equal competition for status among men and, at the same time, in most cases by a definite inequality between the sexes. Men see control over women as a prerequisite for their own competitive activities. The idea of equality is played out in terms of group membership: men are clansmen, brothers. Inequality is sought through relationships established by marriage, the initial points from which big-men attempt to build up their extra-clan networks. Dress and decoration contribute to the realization of these social values and political processes.

Abstract as these formulations may seem, it is important to consider them, because they help us place elements that might otherwise appear to be merely exotic into a recognizable social context. There is little doubt that the same basic aims of competition, declaration of status, and the construction of differences between the sexes also underlie modes of dress and adornment in contemporary Europe and America. To an observer from this part of the world, however, the special advantage that New Guinea offers is simply that in superficial appearances the societies there are strikingly different from one's own. The experience should also, naturally, be true the other way around, and I am reminded here of the Amerindian who asked why European people were in the habit of looking at themselves in the mirror first thing every morning; were they afraid they would die—that is, lose their souls—if they omitted this ritual?

That observations cannot be accurately made without a proper understanding of the workings of a society is shown in the kinds of ethnocentric descriptions that sometimes accompany popular articles on remote parts of the world; New Guinea has had at least its full share of such travelogues. In a *National Geographic* article of 1962, for example, there are descriptions of dress and dancing in the Mount Hagen area of Papua New Guinea's Western Highlands Province. The descriptions mostly accompany photographs, which are themselves of outstanding quality and historical interest. In one, a Mount Hagen man is shown presenting a pile of shillings, earned through the sale of coffee, over a bank counter. He wears on his chest a sign of his participation in the traditional system of wealth exchange, known as the *moka*, and the author writes, "As a symbol of his wealth, the Papuan wears a bib of bamboo strips. Each attests his ownership of ten gold-lipped pearl-oyster shells, the native currency of the region."[1] The writer also attended the first performance of the Mount Hagen Show, at which tribesmen from many different language groups were present in full decorations, having been brought in on foot by Australian government patrol officers. His photograph of a man from Ialibu, south of Hagen, is captioned "Wigged warrior capers in a clown's false face." In both instances, irrelevant or incorrect inferences are brought into the

account. First, the set of bamboo strips, or *omak*, which is diagnostic of men's dress in Mount Hagen, denotes not present ownership of shell valuables but rather the fact that sets of eight or ten of these have been *given away* to partners, for in this society prestige traditionally comes not from possession of goods but from the act of presenting them to others. (Of course, there is a strategy in this: the recipients have to make returns later, and lose standing if they do not give back more! Hence the scope for competition between partners.) Second, the notion that the warrior's face paint is to be compared with a "clown's false face" is entirely wrong, as is the suggestion that his stately dancing should be referred to as "capering." Face painting is, on the contrary, a serious exercise, and its designs make out male status as against that of females.

The observational mistakes that I have identified here result from the observer's automatic search for a comparison from within his own culture. A similar account of a Hagen ceremony is found in a *National Geographic* issue of 1959, where a *moga* (or *moka*) gift of pearl shells is likened to an "American county fair," and a line of dancers is described as "hopping up and down chanting, and the headdresses flopped and bobbed"; at the end there was such confusion that the author could not "really see how they knew which *moga* shells belonged to which people." Finally she wrote, "I have never seen anything so wild and beautiful."[2]

Here all the difficulties are shown very clearly. The scene looks like an American fair only because there is a crowd of brightly dressed people; in other ways the structure of the occasion is quite different. What appears to be confused may actually possess order, since the destinations of the shells have all been carefully arranged in advance. The old men "dickering" in the center, whom the author also mentions, were not bargaining at that stage but ceremonially counting. The "hopping" dance performed indicates that the event was probably staged by a group whose dancing style owes more to the Wahgi Valley culture east of Hagen than to the Mount Hagen area itself (which is populated by the Melpa people). Finally, having begun with a comparison that brings the event "near to home," the observer frames it as "far from home" by calling it "wild" as well as the obligatory "beautiful." Yet how *is* one to achieve a valid account of other people's ceremonies and decorations without falling into quite the same trap? My knowledge of the Hagen area, gathered during several periods of fieldwork undertaken there since 1964, may enable me swiftly to spot obvious ethnographic errors or gaps, but it will not necessarily carry me through to an appreciation of the people's own aesthetics and symbolism. For this, only detailed study of the decorations themselves, the contexts in which they are worn, and what the people themselves say about them can be of help.

The incorrect image of the "clown's face," caused by the fact that Highlands New Guinea men sometimes apply red and yellow paint to their noses and cheeks, can now be considered further. The author of the image has interpreted the face painting as a kind of *mask*, designed to represent a character-stereotype—here, a clown. In the clown mask any individual features of the wearer are subordinated to standard features, which signal to the audience the

personality of "clown." The individual is suppressed in favor of a public role. Something like this is also happening with New Guinea face painting, but it is not exactly the same. To pursue the question, we can examine some cases where actual masks are worn.

As it happens, masks are not very prominent in the Highlands. There are the famous "mud-men of Goroka," who seem to be as much a product of tourist brochures and Highland Shows as anything else. And there are gourd masks, worn in parts of Southern Highlands by men impersonating spirits. Also, elaborate masks are worn by the Gimi people of the Eastern Highlands for dramas and farces; they have been described by the anthropologists Gillian and David Gillison (earlier, too, by Leonard Glick). In one of these dramas, a prenuptial rite, male dancers represent the sun and moon. Their actions, and the stripes of white paint on their bodies, stand for light, which in turn refers to men's knowledge, gained from their travels outside their home village. The dancer representing the sun wears a bark mask that emphasizes his eyes, appropriately thought of as centers of awareness. Another masker, his face entirely hidden and his body covered with large leaves, represents the large cassowary bird and thus also the mysteries of the forest.

The techniques of representation here are similar to those discovered by another anthropologist, Alfred Gell, in his study of the Umeda people of the West Sepik Province, close to Papua New Guinea's border with Indonesian-controlled Irian Jaya (previously Dutch New Guinea).[3] Among the Umeda, the black cassowary mask represents not only the forest, as with the Gimi, but also the particular status of the senior men in contrast to the juniors, who inevitably will supplant them in society and who appear in the main fertility ritual, the *ida*, as bowmen, painted in red. Dancers representing these characters in the sacred drama thus definitely don a specific identity symbolizing important social values and themes. Face painting also symbolizes such values, but less directly and with a lesser suppression of the individuality of the actors themselves.

The example of the Umeda is worth discussing in more detail, especially since Gell's accounts are extraordinarily sustained and precise. The *ida* ritual involves the appearance, in sequence, of sets of masked dancers, each with a stereotyped name and costume. The chief masks are called cassowary, bowman, sago tree, neophyte, and preceptor. They are all worn by males, who must refrain from sexual intercourse, eat only traditional foods, and stay within the confines of the village during the period of the ritual. The cassowary dancer's identification with the real bird is shown in the rule that he must not hunt it and he must not even enter the forest because all the game animals would follow him. Further, all dancers appear in sets of two, symbolizing the principle of binary division—of which moiety structure is an example—that is important in Umeda social organization.

The cassowary pair wear masks topped by sago fronds, and "are painted black all over with charcoal, without additional decoration." They leap from one foot to the other so that the penis gourd each wears flies up sharply and strikes a row of hard sago seeds worn around the abdomen. They begin dancing at about nine o'clock in the evening and must continue until five the next morning with only short pauses. Two neophytes described as *molna*

tamwa—which is translated literally as "fish of the daughters," or the junior generation—dance with them. They wear smaller penis gourds and walk around sedately, thus presenting a much more controlled, immature, and less florid spectacle than the cassowaries. At dawn, cassowary is replaced by sago. These dancers wear the same mask as the cassowary, but their body paint consists of broad horizontal bands of yellow, red, white, and black, plus black markings on their joints. As they dance, senior men heat stones on a fire and drop them into water to make it boil, pouring this over sago flour until it solidifies into a jelly. Each dancer then plunges his hands into the boiling sago and throws it into the air, followed by all the men; the women retire at this point, since they are not supposed to see this part. The action is very painful and represents a climax in the ritual as a whole.

The climax is followed by the appearance of pairs of "bad" and "good" female fish, each distinctively painted (all black with splashes of red or yellow and circular white marks, versus regular and naturalistic colored designs resembling actual fish or tree species). The bad are old and represent Ahoragwa, a toad woman; the young are good and represent Tetagwa, a mythical heroine whose name derives from a brightly colored, succulent fruit shaped like a woman's breast. The young men who dance in this role are also given license to display themselves at their most attractive and provocative in sexual terms, under literal cover of their masks and overall body painting. More minor characters follow them with a distinct touch of buffoonery and—yes—clowning. One is *yaut*, a fiend, who at first terrifies the children watching the display, and then allows himself to be driven off "with shouts and a shower of sticks, rubbish or anything else with comes to hand." Another clownlike character is *amov*, termite, whose face is hidden with yellow-dyed underbark, which imitates the head of the real termite. He has a base of red body paint, to which are added diamonds executed in black and yellow with white circles. He dances sedately and, like the neophytes, is followed by a singing mass of small boys.

The red bowmen appear last and are second in prestige only to the cassowary dancers. Their masks are smaller versions of those worn by the neophytes, except that they are fringed with material taken from the white inner heart of the crown of a particular palm tree, the *limbum*. Their red body paint is also modified by two long stripes from shoulder to toe or twin circles on the back and abdomen, both executed in black. The stripes are known as the young cassowary designs. The bowmen are accompanied by two old men who act as preceptors; they are undecorated and have no body paint. The bowmen pace very slowly and deliberately: Gell likens this gait to "power held on a tight leash." Finally, at sundown on the second day of the dance, the bowmen face west and shoot their arrows into the bush, beyond the village enclosure. Then they drop their bows and race for the dancers' enclosure. The ritual is over and everyone goes home.

How does Gell analyze these acts, and in particular the masks and body painting? There can be little doubt that a systematic code is somehow at work and yet the anthropologist found that people could not, or would not, explain it all to him. Essentially, he had to construct the analysis by himself, but he did so by minute reexamination of his actual data.

Another research worker, Bernard Juillerat, discovered while based in a neighboring area that in fact there is an underlying mythology that can be used to interpret the ritual, but this either did not exist in Gell's area or was at any rate not revealed to him. What is interesting is that his own interpretation is obviously closely in line with what the mythological picture also suggests. His own circumstance as a field-worker was that he was classified as a young, unmarried man who should not know all the secrets. So he records:

> Nobody ever said that *ida* directly induced human fertility, and when this was suggested to them by me they merely looked embarrassed and denied it. Human reproduction (as opposed to sexuality) was a taboo subject among the young men with whom I mainly associated, and older informants tended to be secretive or facetious.

Overtly, the ritual has to do with the abundant reproduction of sago itself. Covertly, however, there is also a reference to human fertility, but this is combined with a concern for the correct transmission of social relationships between generations of men. Through the ritual, the cassowary with his all-black body paint is transformed into his successor, the red-painted bowman, by the regenerative act of boiling and throwing up sago jelly, at which the men cry, "Its head rises up!" referring to the growth of sago palms. The crucial sequence of the main masked dancer is thus cassowary ➤ sago ➤ bowman, while subsidiary masks are further expressions of the values of seniority and juniority shown in the cassowary versus the bowman opposition.

Actual cassowaries are large flightless birds of the deep forest. They are aggressive fighters and hard to catch. In Umeda myth, the ancestors killed a cassowary in the bush and its bones turned into men while its blood and flesh became women; these together founded the neighboring village of Punda, from which Umeda men take wives. The senior generation is thus pictured as resembling autonomous and sexually active creatures of the bush, or people from the outside, from the next village. By contrast, the bachelors, represented in the ritual by the bowmen, are supposed to be sexually chaste and devote themselves to hunting. The meat they obtain must be given to their elders, and they receive back only a portion of it. Their life is under restraint, and they must keep themselves neat, tidy, and well adorned with chest bands, pigs' teeth, feathers, ferns, and beads, even though older men may go unkempt and act as jokers and buffoons if they wish. The cassowary dance represents to an ideal degree this relative autonomy and sexuality of the mature, married men, but it also foreshadows their inevitable decline and replacement. The first sign of this is in their accompaniment by the fish neophytes, whose red paint and sedate movements mark them as junior and whose fish character indicates the idea of multiplication, which is also found later in the sago and termite dancers. Unlike the cassowary, these neophytes, too, carry a bow, the sign both of hunting and of bachelorhood.

Gell's analysis further extends to a detailed consideration of the actual construction of the

masks and the patterns of body painting. The center of the cassowary mask is the upright man himself in a position analogous to that of a tree trunk. The mask's head is made from dark sago fronds and white *pandanus* (screw pine) crowns, the body from underbark of the *gnetum* tree. The latter construction has female connotations, since underbark is used by women to make cloth and string bags; thus the male dancer thrusts his head through a female covering that envelops and hides him. In other words, the act of wearing the mask is a direct representation of sexual intercourse, and the dance is an orgiastic one, celebrating the apogee of "the developmental cycle" of existence, as Gell puts it. To ensure the reproduction of society, then, the cassowary must be metamorphosed into the bowman.

As we have noted, the transition is achieved by the cooking of sago. The sago dancer, called *aba*, stands for the uncooked sago substance, which congeals in boiling into jelly, *yis*, that is explicitly compared to male semen. A complex of ideas comes together here: sexuality, heat, and the act of cooking by fire are all linked. Moreover, in reproduction the man's role is to feed the young embryo with his warm semen. Such an activity depletes the man's stock of semen—an idea that is also very common in the New Guinea Highlands—thus causing his own entropy while building up his progeny. Orgasm is also described as a kind of fainting or dying. The boiling of sago grains and the dismemberment of the congealed jelly stands, then, for the point of orgasm, and the destruction of the sago in the climax of the ritual is also the destruction of the cassowary and the creation of the next generation. The next phase, in which the senior generation is represented by the unpleasant toad figure and the junior by the delectable wild cucurbit fruit (Ahoragwa and Tetagwa, as explained above), shows a move toward an increasing valuation of the young as against the old. Tetagwa wears a *tamwa* mask, which signifies fish; in dream-augury, if fish appear, the birth of children is foretold. The use of coconut fiber for this mask also reflects the "legitimate," or cultural, role of Tetagwa and her children, since coconut fiber is a material used in the process of leaching the basic food-stuff, sago. Coconut stands for ancestral values in the society, as coconut trees mark the site of the village.

Finally, the bowman himself appears. His penis is bound—a practice called *kynodesme*—as a sign of restriction, with a strip of pure white material from the heart of the black palm-tree crown, which is also used to fringe his coconut-fiber mask. His name, *ipele*, suggests in the Umeda language that he himself is as the young breadfruit is to the mature coconut, or as the eldest son is to the father. His dance movements are jerky and rigid, since he is a "new man." Whereas the cassowary dances for seven hours, the bowman does so for only ten minutes prior to loosing his arrow. The arrow itself is a symbol of masculinity and individual achievement, yet it also marks the ascetic status of the bachelor as hunter, his sexuality turned to killing game rather than copulating with women. So it is the junior, not the senior, generation that here represents society and its order, while the cassowary stands for the autonomy that is next to chaos. The cassowary invades from the bush; the bowman fires his arrow outwards into the bush, thus reversing the cassowary's action and renewing the

world. The further significance of the action is not very clear, although it is obviously decisive, since after it the whole ritual abruptly ends. The point has been made, and everyone at once turns for home.

It is obvious from this discussion that analysis of the *ida* has to take into account the masks worn, the body paint, the dance movements, and the linguistic evidence, as well as the overall fit of any interpretation with Umeda social life as a whole. Body painting is perhaps particularly striking here, since the whole body is painted, except for the dancers' heads, which are of course enclosed in their masks. The clearest symbolic opposition lies between cassowary and bowman, with their master contrast of black to red (a contrast parallel in structure, if not in meaning, to the major distinction employed in Hagen face painting, to which I will turn later). Gell finds that this opposition is neatly shown in the form of the black palm crown. In this, the inner part is white, as opposed to the outer, which is dark; and the white is also immature as opposed to the mature, with bright colors such as red and yellow indicating a transition between these two. It will be recalled that the "newness" of the bowman is emphasized by his penis binding, made of the white inner part of the palm crown. White is also the color of the most potent magical substance, a white loam dug from the ground. Red indicates growth toward maturity, and young people should not eat those creatures, such as red fish, that are thus identified with themselves. Children's buttocks may be brushed with a red herb that has the same name as the red ocher used for body paint. Black is the color of ghosts, of the forest darkness beyond the village fires, of violence and terror: warriors cover their faces and bodies with charcoal; male heads of families keep blackened smoked meat in baskets for distribution to their juniors. In myth Toag-tod, or "smoked-meat man," is the name of an elder brother who is defeated by his younger brother, Pul-tod, a red-skinned man. The associations here are all very clear and follow the explanations and interpretations of the ritual given above.

But why body painting as such? What does it do? As Gell says, "A new or modified skin is a new or modified personality." In effect, there is a play in language between skin as "exterior self" and skin as a "whole body." (Again, this is paralleled by Hagen usage, and even more definitely by usage in Wiru, a language of the Southern Highlands.) There are myths of old and ugly people removing their skins and becoming young and beautiful. The skin, if we may extrapolate from other instances of symbolism in New Guinea societies, is also maternally derived and its well-being is dependent on maternal kinsfolk's goodwill. Painting the skin red—a maternal color, I would suggest—thus quite clearly prefigures such goodwill and hence powers of growth. Tetagwa, the female heroine, has as her sign a red pendulous fruit—similar to a breast in shape—even though breast milk is white and Umeda women's breasts are not classified as red.

There are probably similarities here between these New Guinea ideas and those concerning female makeup in European society. Rouge, at any rate, is synonymous with good health, while pallor is equated with sickness. Rosy cheeks prove that rickets are not present, and country girls are expected to possess them. Nonetheless, there is an overall difference, I

think. In contemporary European usage, the entire potency of makeup is dedicated to enhancing the individual sexual attractiveness of its wearer. The style of makeup certainly also reflects social class, but its relationship to collective values and aspirations has become submerged in an emphasis on the individual. Correlatively, skin ceases to be something that is affected by social relationships with others. It becomes instead an artifact to be managed by technological experts: beauty salons replace sacrifices to the mother's brother. This is not to say that beauty magic or beauty technology is an exclusive possession of industrialized society. Evidence from the Trobriand Islands (on the southeastern tip of New Guinea) convincingly refutes any such notion. It does mean that in western society there is an individualistic ideology specifying the connections between skin and the person that excludes social relationships as cause and sees them only as a result of individual qualities or manipulation. I will return to this point later.

In the *ida* body painting, we start with an all-black cassowary, juxtaposed with an all-red fish neophyte (how black here becomes associated with sexuality and not violence is not completely clear). He is followed by sago, whose blackness is modified with red markings, and then by a set of dancers who can only be described as motley, all wearing fish masks; cassowary and sago both wear the sago mask. Finally, the bowman is predominantly red, but with significant black markings, and he contrasts with the unpainted preceptor (who, however, is naturally dark—a faded version of the vivid black cassowary himself). The dancers actually always appear in pairs, each man representing one of the two moieties in the village, and these moieties are each considered male or female. The "male" moiety bowman wears vertical stripes corresponding to the male axis; the "female" one has round circles just above the buttocks. Gell comments that "I myself, addicted to such diagrams, could not conceivably do better, albeit the sociological significance of these designs is entirely unconscious where the Umeda themselves are concerned." The black vertical markings are called "cassowary-chick," however, and the circles are "female (frog) growth spirit eyes," so one wonders if the significance is as unconscious as Gell states here.

There is a final element to be noted, illustrated clearly in this last example of symbolism: that is, the complementarity of, and the opposition between, the sexes. The ambivalence with which Umeda men, Gell's informants, view human reproduction is probably linked to the theme of inevitable male depletion in sexual intercourse. There is a mythical secret at the back of the *ida*, which is widely found elsewhere in New Guinea, in Melanesia as a whole, and in South American Indian societies. The secret is that it was women who originally possessed the ritual and that men stole it from them by a trick. The men captured many pigs, cooked sago jelly, and made a feast for the women, who ate until they "died"—that is, fell asleep with their legs apart. The men copulated with them and then broke into the secret enclosure where *ida* masks were stored, and began to perform the ritual. The women woke and said, "We're no good, we fell asleep. From now on, *ida* belongs to the men." This story, undoubtedly told by men, is the charter for male ritual superiority over women, even though the ritual itself both displays the necessity for male and female principles to be conjoined and

suggests that the cassowary has curiously female as well as male attributes. Indeed, the possibility of interpreting ritual symbols in contradictory ways emerges frequently. The bowman and the other red dancers, for example, are associated with female powers of reproduction and menstruation, although the bowman is also the quintessential bachelor, and bachelors are segregated from sexual contact with women. Themes of this kind are practically universal in Melanesian art, and form much of the driving force that underlies the production of masks, costumes, and body painting.

I have discussed the examples of Umeda masks and painting in some detail rather than treating them just as interesting but isolated cases because the themes of Umeda ritual recur again and again in the rituals of other New Guinea people. We also now have an idea of what masks and body painting mean to these people. Both mark the assumption of a dramatic identity that has a hidden set of associated meanings, and both indicate the total assumption of this identity for the purpose of the ritual itself. They are thus an extreme form of representation that goes one step beyond the Highlanders' decorations and face painting. In Hagen, for example, dancers do not assume another identity: they represent themselves, in heightened form. Yet, in another sense, this is exactly what the cassowary does in Umeda: he represents a value-tendency but in exaggerated form, in order to contrast maximally with the bowman.

In the next section, I move to the East Sepik area, home of so many celebrated artistic and ritual traditions in New Guinea.

Sepik carvings are the sine qua non of every tourist shop in Papua New Guinea, every art catalog, every self-respecting museum. To my knowledge, the reasons for the astonishing efflorescence of this art form in the Sepik have never been thoroughly established by anthropologists, and—like the origins of clothing—they probably never will be. Sepik societies are characterized by a very high development of initiatory grades as well as of moieties, and the carvings and paintings are always associated with these. Further, the prevalence of such systems of initiation can be linked to the existence of a gerontocracy—as opposed to the Highlands emphasis on competitive "big-man" leadership, although the latter is also found in the Sepik—overlaying the familiar and practically universal differentiation of the sexes. Elaborate developments of both carving and initiation systems occur in areas of high population density, but all these features are only weak indicators of pattern and do not provide decisive clues as to causes. It would be hard to argue, for example, that art is a product of coping with ambivalence or other pressures and that such pressures are greater in the Sepik than in the Highlands areas.

As with the problem of clothing, we are forced to abandon speculation, and resort to a method that is more amenable to use by anthropologists—that of controlled comparisons. This is the approach used by Anthony Forge in his studies both of the Iatmul, who were originally investigated by Gregory Bateson, and of the Abelam, who were observed by Forge himself and earlier by Phyllis Kaberry. These two peoples, Forge points out, have similar lan-

guages and social structures and attach great importance to art and ceremony, but they have very different economies. The Iatmul primarily depend on the vast Sepik River for their livelihood, while the Abelam live on fertile ridges at the foothills of a mountain range. Some aspects of material culture therefore differ between the two societies, but Forge argues that "apparently disparate objects may serve very similar symbolic functions in the two societies." He also proceeds, as Gell does (indeed, Gell's approach follows that of Forge), to suggest that an analysis can be made even when the people themselves offer no explanations for their art: "Any systematic symbolism must be at the level of the relations between symbols, and at this level may not be consciously perceived by either the artist or the beholder."[4] If one can elucidate this underlying pattern, Forge maintains, one can even ignore the overt meaning of the symbols and in so doing protect oneself against being blinded by "first-level details."

For his exposition, Forge concentrates on the huge ceremonial houses with their soaring ridgepoles—a design celebrated nowadays on a thousand postcards and imitated in the design of post offices, cultural centers, and Catholic churches. Among both peoples these houses are classified as female, yet no woman is supposed to enter them; the houses are to serve all the men of different clans in the village. At each gable of the Iatmul house there is a huge face—the face of the house itself—and its corners are surmounted by carvings of a man or woman with a fish eagle perched on the shoulder. The interior of the house may be called its belly. Since boys are initiated in it and initiation carries overtones of rebirth, the symbolism already begins to become apparent, and to fall into the familiar pattern of men claiming control over regeneration through the cultural construction of female symbols.

The house is female, but its ridgepole—which may be fifty or sixty feet long—is male, and has to be dragged to the construction site without being seen by women or children. Men purify themselves by bleeding their penes to rid them of traces of sexual contact, then struggle to erect the pole before dawn, in order to tell the women in the morning that the pole came by itself. The obvious effort they put into this seems inconsistent with the fact that no one appears to expect the women to believe the story, yet the task must be done! The pole has a hole at its top through which a rattan rope is passed; the rope is identified with spirit pythons and contains at its end two wild-pig skulls. At a late stage, a wooden appendage is fastened to the end of the pole after thatching, and pots—made by women—are placed on top of this to form a smoothly rounded top. Finally the man who places the pots shouts the spearing cry of his clan and hurls down a coconut, which his fellows, shouting, converge on and smash. Another man lets the rattan fall. For the ensuing dance, the rattan and its tassels are decorated either with a tally of orange seeds—which stand for dead enemies—hanging from spear points or with small manikins made from burrs. All these acts clearly symbolize the defeat of enemies and the killing of captured prisoners. According to Forge, they also indicate a common symbolic identity among heads, coconuts, and male testicles. Decorations for the dance celebrating the house construction also consist mainly of these orange seeds and of "a device made from portions of white palm efflorescence and red leaf," which

represent the men's sexual conquest of women from villages around. Among the Iatmul, eagles that perch on the houses' gables additionally connote warfare and anger: this is appropriate, since the eagle is in fact a fierce hunter bird.

Given the apparently obvious symbolism here, Forge tried out his own interpretations on his informants, suggesting that the carved end of the ridgepole was a penis. The men said no, it was a nose, and a nose could be bored into but a penis could not be, so that the pole could not be a penis. This was an answer that of course served only to reinforce the association in the anthropologist's mind, since the equation between nose and penis is well established in western psychological theory, and Sepik carvings in which the nose practically joins with the penis are also commonplace! (Gilbert Lewis, who—like Gell—worked in the West Sepik, had similar experiences when he suggested that the male bleeding of the penis at initiation was a kind of male menstruation: his informants simply denied it. Was it just that he was getting too close and they wished to put him off, or are our psychological inferences somehow rather crass?) Forge moves on from this question to make the important point that even if we know, or think we know, that the symbolism is sexual, this does not make it self-explanatory.

Following Gell's detective work in unraveling Umeda symbols, we found that sexuality and phallic imagery are linked in Umeda society to a particular vision of the succession of generations, which Gell calls "the nemesis of reproductivity." What, then, is the particular complex in which Abelam and Iatmul ideas are situated? The notion that it is dangerous for men to be in contact with women is extended to agricultural activities among the Abelam and Iatmul, as it is to hunting among the Umeda. For the Abelam, the belief is tied to the growing of long yams, which sometimes reach a length of twelve feet. Men who grow these must purify themselves by bleeding in the same way as the men who erect the ridgepole and in addition must not cohabit with women, must light their own cigarettes, and must ensure that their wives do not commit adultery and so bring contamination to them through preparation of their food. Purity is here assumed by married men, whereas it is confined to bachelors by the Umeda. The yams are produced to be given away, and when displayed they are decorated with basketwork masks similar to those worn by men for dances. The biggest yams are usually also named for the clan spirits of their owner, and these spirits are ultimately responsible for the yams' powers of growth. Male potency, preserved from actual sexual contact, is thus channeled into the production of food with a phallic appearance and significance.

This point emerges from the study of paintings of the clan spirits themselves, which all have large penes with a drop of semen painted on the end and sometimes a pig sniffing at this. The white semen is definitely seen as a form of nourishment, and is compared to the white mud that, as with the Umeda, is used as a magical pig-fattener. (This usage of white is widespread. In the Hagen and Wiru areas, the same basic notion is found. Crystals are used in pig magic, as is a type of plant whose dried leaf has a name, *pembe*, that refers to the quality of whiteness.) To support this idea, Forge further considers the motif of flying-fox faces

that regularly appear in a band of house facades. These faces are marked as female by the use of a feather ornament worn specifically by women, but beneath the face there is a central white stroke called "the breast of the flying fox." The stroke is in fact the penis of the male flying fox, and the figures are therefore male-female composites, bringing together in a single body the separate ideas of male and female nourishment.

Pulling his discussion together, Forge concludes that the phallus, as represented in Abelam and Iatmul art, has at least three aspects: first, as the ridgepole, encompassing the ridgepole's association with violence; second, as a nutritive organ in carvings of the clan spirits; and third, as a combined symbol of aggression and nutrition, in the long-yam cult. In the case of the Iatmul, an emphasis on yams is replaced by ritual stress on long male flutes, since yams cannot so readily be grown in the Iatmul area. Flutes as male or male-and-female symbols are also widely found in secret cults throughout the Highlands, so that, whichever way we turn, we seem to uncover elements of cultural complexes that are ultimately related, and which always revolve around aspects of relations between the sexes and statements about gender identity. Sepik masks and house paintings are thus brought within the same analytical purview as the study of the Umeda dances and body painting. Since the Abelam also practice elaborate face painting for their initiations, it would be interesting to include this element within the discussion, but unfortunately there is no full publication that could provide enough solid information and analysis at this time. We are also left with the same puzzle that we found in Gell's analysis: the apparent lack of informant exegesis and the anthropologist's consequent tendency to study context and fill in the gaps with ideas derived from psychological theory in the first place. I turn to this problem again now, using some materials from my own fieldwork in the Highlands areas.

In an analysis of self-decoration among the Hagen people,[5] Marilyn Strathern and I initially faced all the difficulties recorded in Forge's and Gell's anecdotes. Decorations were obviously elaborate, painstakingly assembled, brightly colored, and impressive, and central to dancing occasions. In general, it was obvious that many of the items employed were also wealth goods used in exchanges and that persons were displaying this idea of wealth on their own behalf or for others. But specific inquiries about the meaning of pieces of decoration were consistently met with the phrase "it is just decoration" (in Pidgin English: *em bilas nating tasol*). We had to revise our approach and work from the context back to the items to see if clues would emerge, and in so doing we repeated many of our specific questions whenever they appeared relevant or useful in any way. Since a society such as that in Mount Hagen has not generated from within itself the role of anthropologist, and since its own knowledgeable ritual experts (the nearest analogue) are concerned above all with keeping their information to themselves because it is an important resource of their livelihood (some anthropologists' uses of jargon or attitudes toward publishing their results appear to be similar to this pattern), it should not be thought surprising that a systematic exposition is not readily available. Recently, Ron Brunton has argued that we may in fact be mistaken in even looking for order-

liness. He suggests that this is instead simply a preoccupation of intellectuals rather than of the people they study, since for people whose ideas are not subject to the same emphasis on consistency, "the pressures to create an ordered world-view are less intense." He uses this starting point to criticize Gell's analysis of the *ida* masks that I reviewed earlier, and he argues that "Gell does not consider the possibility that certain aspects of Umeda understanding may be confused and poorly codified. Nor does he examine the sources of innovation and decay."[6]

Brunton's general point here is well taken, although the details of his attack on Gell appear to have misfired: instead of being confirmed, Brunton's theories have been attacked by the French anthropologist Bernard Juillerat, who maintains that Umeda religion is even *more* systematic than Gell thought, that there is a relevant myth which underlies the *ida*, and that this myth has indeed to do with the reversal of relations between the sexes about which Gell's version is also explicit. Gell himself is taken to task for not discovering the native exegesis that Juillerat's research found to exist!

For the Hagen study, we neither assumed order nor abandoned the search for it simply because evidence was fragmentary. Instead, we tried to pay close attention to what people did say and to systematize their statements in the form of a model, more as a working tool than as a claim that the model literally represented a Hagen "theology." What emerged from this was that it was helpful to concentrate on color symbolism and to correlate broad tendencies, if not precise details, in ceremonial face painting, with the major social occasions when dances were performed. The leading color motif was an opposition between the dark and the bright; this was represented chiefly by the colors black and red, which connoted male and female. Such a generalization greatly oversimplifies, but it is a valid guideline. Men's wigs are normally dark, and their faces colored with charcoal; women's faces are much more brightly painted, with a base of red ocher rather than black. The pattern is not absolute, since men always have markings of white or red/yellow on their noses/cheeks (the pattern that inspired the inappropriate dubbing of their designs as "clown's faces," discussed earlier). In another sense, both men's and women's plumes should be bright and shining rather than dark and dull, and their skin should be gleaming and healthy, as a sign of favor from the ancestors. Decoration is the opposite of smearing mud on the body in mourning, and the people say that pig's grease rubbed on the skin gives them a feeling of well-being, whereas the caked yellow mud smeared on at funerals feels uncomfortable—perhaps like the flaking skin of the dead person?

In terms of social values, our main suggestion—based on people's own statements—was that black face paint represents the internal group solidarity of males and their aggressiveness toward outsiders, while the bright colors of red and yellow stood for female values, sexual appeal, and intergroup friendship, affinity, and exchange. Finally, we saw the color white as mediating between black and red, but attributed largely to the male gender. Its mediating position is perhaps most clearly seen in its prominence within the Female Spirit Cult, for which the men don round wigs that are white in color and also wear at one side the white plume of the goddess herself, at the other the Red Bird of Paradise plume that in this instance

represents the men themselves—the "ordinary" as against the "extraordinary" plume. The white color is explicitly said by the participants to stand for the character of the goddess, who encourages friendship and banishes sorcery between groups. She appears as a beautiful virgin dressed in a bright straw apron and wearing shining neck-shells between her breasts; she comes in dreams to men and tells them to institute her cult. At the same time, she is not like ordinary women, who menstruate, and hence is not herself "red" or "black." Her dissociation from and even opposition to mortal females is shown by the fact that she—that is, her male cultists—forbids women to take part in the cult; she will turn a woman's apron back to front should the woman by mistake see one of the cult stones or a cult action. The goddess is thus arrogated into the sphere of "male" reproduction, which is opposed to women.

The values and notions that emerged in informants' statements and our own reordering of these into major color-sets can readily be compared, I think, with those independently established by Gell and Forge both before and after our study, although we thought of ourselves as building on what people said rather than relying entirely on our own theories. During the period from 1978 to 1980, many years after the first inquiries were made, I returned to the problem of decorations and also extended it to my second field area among the Wiru people of Pangia, some one hundred miles to the south of my Mount Hagen base. There were some interesting results in both cases, for I found a much more systematic set of ideas about birds and their role as symbols of certain social values than I had previously supposed. Since I have discussed at length the views of the anthropologists, I want now to give space to the accounts of the people themselves, for this whole question is indeed one of the biggest lacunae in the literature. What people have said to the anthropologists tends to get worked into their own texts to such an extent that one can hardly tell where one leaves off and the other begins. Thus, for example, in Faris's striking study of Nuba art, we are told several times about "rules" of appropriate and inappropriate designs and of criticisms and advice that people volunteer to each other. There are also severe sanctions that supposedly come into play if some of these rules are broken. For example, "girls are under sanction not to change their colour, particularly along the red-yellow axis. If they do, a severe crippling disease is said to result, which particularly attacks the knees [and thus affects their ability to dance at all]."[7] In this case it is clear that the rule is consciously, indeed elaborately, maintained among the Nuba. Nonetheless, the "grammar" of decorations that Faris builds up at the end of the book could have been formulated both from such rules and from his own observational generalizations. If so, we need to be able to distinguish between the parts of the analysis that directly derived from the people's testimony and those parts that derived from observation. But if only as a check on one's own speculations, there is value in acquiring longer statements from informants, ideally as comments on a particular performance that both the investigator and the informant have seen.

I give first two discussions with friends in Mount Hagen, Ongka and Wömndi, whose accounts of Hagen culture and society I have also juxtaposed in a recent examination of the

concept of *noman*, or "mind," which is important for the interpretation of decorations as well as for the comparison of Hagen and western ideas. It was in this context that Wömndi's responses confirmed the kinds of statements made earlier in *Self-Decoration*, while Ongka's pushed the discussion forward into a new dimension and linked it to what I was learning from the Wiru at about the same time. So I begin with Wömndi's words and with my own in leading into the discussion, which has been translated from the taped Melpa (Hagen) original:

A.S.: This is April nineteenth, 1980, and I want to ask you something. It is about this: What kinds of ideas do people have in decorating themselves for dances? I've had a letter from a European man [Malcolm Kirk], and so I'm asking about this again.

wömndi: All right. I am Wömndi, and now I am going to discuss this matter. This European has written a letter to Andrew and asked him some questions about decorations, so he is asking me to say what the basis for them is and put it on the tape recorder. In Hagen, we men and women, both sexes, we have to stick at our work all the time, it is hard and we carry on with it, we raise pigs; both men and women, all of us, we keep on at it, we walk around in the gardens and bush, hidden from view, and so when we cook pigs, or set up stakes in order to make *moka*, or give the pigs away in *moka* itself, we say that we want people from other places to come and look at us. We want them to come and say, "Which man has just given this huge pig for the *moka*, which woman has reared it and digs up sweet potatoes to feed it?" And so someone can reply, "Ah, it has been given in the name of such and such a woman, and such and such a man." The woman who has given it dances up and down the line of pigs beating a drum which we [men] give her, while the man who has given it puts on his special headdress and races up the line also, he counts off the pig stakes, his wife does the same.... There is no other reason for this, it is because of the work which we do, we walk around in private, and so we put people on a public stage. We cook pigs, we make *moka*, the women decorate, paint their faces, put on eagle feathers, while we men put on the plaque headdress, we wear our long front aprons. That is why we do it, because we work and we want to bring ourselves out into the public gaze again. This is something our grandfathers long ago did, and we their sons do and our sons also follow now....

A.S.: Just one point. When people watch a dance, they comment on the dancers, saying that one has good decorations and another bad. What is it that they are referring to here?

wömndi: Yes, this is what spectators from other places come and say, that these people's decorations are good. "Their plumes are bright and shining, their face paint is bright also, their aprons are worn straight and long, they have put pig grease on their skins and it looks good, so we look at them and we are pleased"—that is what they say when the decorations are good. But if they look and see that the dancers' decorations are bad, that means that one of us will die. If they are bad, both men's and women's

decorations, then it is true, someone does soon die after the dance is over. But if they are good, we shall not die, no one will die in the near future, nor shall we get into any trouble. We shall be able to put on another show quickly, too, to cook pigs or give money away to another group, and they will say of us again, "They looked good as they carried it out." But if our decorations are dowdy, the plumes lack luster, the marsupial furs are dull, and the grease we put on fails to make our skin shine, then truly we shall get into trouble soon, one of us will die, and if we go to the place where we have given the pigs, we shall not recover our debts quickly. This point is true of good decorations also. They indicate that we shall be able to go again quite soon to our partners and they will make returns to us for what we have given.

A.S.: Does the man whose decorations and dancing have been bad realize that?

WÖMNDI: Yes, they do realize. People remark on it and they hear.

A.S.: They hear and are ashamed?

WÖMNDI: Yes, they are ashamed. People say that their aprons have fallen down, their back belts have fallen down, their rear-coverings of leaves have slipped down, too, they keep on feeling thirsty, they say, "I don't want to do the *mörl* dance nor the *kenan*. I hope the sun will go down quickly and they can take off their feather headdresses, and so I could leave this and go home and sleep, what are we doing this for, it will do us no good"—that is what they think. When the dance is good, the spectators themselves say, "This is good, don't stop, don't take off your feathers, keep at it." This is because they like it so much. The performers hear this and hear others talking about it also and they are encouraged to continue.

A.S.: Can you think of a time when you went to see a dance and it was good?

WÖMNDI: It happens everywhere all the time, one doesn't count individual places. Sometimes when people dance it's good, and at other times, it's bad. If it's good, their feathers, furs, and grease all look fresh, but if it's bad they all look dusty and dull [literally dark, as if coated with soot from a fire], and we the spectators come home quickly before the day is over and say, "The dance was turned into confusion and we disliked it, so we left it quickly." But if it was good, we praise it and we feel happy, too.

A.S.: If a dance is bad, do you say that the ghosts failed to help the dancers?

WÖMNDI: Oh, yes, if a dance is bad, yes, that is what they used to say, now they say that the *pukl wamb* of the dance [either the ghosts or God] has turned it into confusion; we say that our Creator must have felt upset about the dance and made it bad.

A.S.: Another phrase. When people see a man's face darkened with charcoal and say "the whole spirit is there," what do they mean?

WÖMNDI: If the men's faces can be seen too clearly, we say, "Oh, we went to that dance and even from a distance we were able to recognize the men early, it was no good." So they put on a lot of charcoal to make their faces really dark as night and prevent their recognition, so that people will praise them. They say, "Hey, we can't recognize these men, this is a good dance performance." [He laughs at the thought of this.]

Some don't bother about this, they just wash their faces and put on colors, but older men think that it will be bad if they don't charcoal themselves heavily.

A.S.: Over in the Wahgi Valley to the east, there they don't put on charcoal, do they?

WÖMNDI: What? Oh, some of them do, a few of them. In our case, when we want to dance, we charcoal the whole face and then we wipe it off the nose and we paint the cleaned parts with bright colors. There is another practice. We make cones out of cassowary feathers bound onto supports and stick these all over the head, on the wig, and for this the man covers himself completely in charcoal, top to toe, and races out, he looks like a bad dream or something. [Laughs.] There are two of them, one races ahead and the other chases him, very close, and we say, "Look, a big-man wearing the cassowary cones!" It is quite a feat. They don't wear rear-coverings in the ordinary way, they just cover it all with charcoal and race out, they are so dark! They do that to make a bit of a name for themselves.

A.S.: I've never seen that.

WÖMNDI: Yes, they used to do it. Since you came [1964], they've not been doing it. It was done for either pigs or shells, when these were given away, and people said of the man who did it, "He must have very many shells."

A.S.: In the Wahgi Valley, they say that men dance so girls will be attracted to them.

WÖMNDI: True. The girls aren't interested in the older men, but they like the looks of the younger ones and say they'll go in marriage to them, they go to join them in the dance and the men link arms with them. They do that here, too. A girl may come on either side of the man, they hold on to the man's weapons that he carries or else they actually link arms with him. We say, "Ah, that girl likes him and there she is," and if he's a young man, he actually takes her off home. His parents escort the girls, and say, "Here we have the girls who joined our boy in the dance, we are bringing them home to stay with us and then we shall give them some pay," and they give them some money and beads and send them off. If the girl really wants to marry the boy, she refuses to go, but he may not have the wealth to pay for her. Then she follows him around from dance to dance and joins him whenever she can and so it goes on and on, and if she is very persistent, he eventually marries her.

A.S.: Do men and women have the same intentions in dancing?

WÖMNDI: Yes. Married women, of course, are given decorations by their husbands so they can dance. The husbands think, "My wife is always digging up sweet potatoes for food and working hard, we both work hard together, so now if only I dance and she doesn't, she will be angry, so let us both decorate." They ask her own kin to bring plumes and other things for her and they pay them for this. This is called "giving sweet potatoes for the plumes," it is in reference to when she would take the plumes off, and her parents and brothers would say, "He's decorated his wife for nothing," they would be annoyed and our children would get sick, and so we pay them.

Sometimes they bring a pig even, or money, and then we give them more, recognizing them as our wife's kin.

A.S.: I know five dances: the men's are *mörl* and *kenan* and the women's *werl* and *mörli*, and there is also *kng kui*.

WÖMNDI: *Mörli* is just a game, an amusement. The real dances are the ones for which people wear plumes and furs.

A.S.: The up-and-down movement from their toes that men do in the *mörl*, what does that signify?

WÖMNDI: Why, that is so when their knees bend with the movement, their long aprons will swish forward and people will see it, and at the same time their feathers sway backwards, so people will look at these plumes as well as at the apron. If someone flexes his knees poorly, they criticize it sharply: "What sort of a knee bend is that? He should be looking up and down the row of men and making sure he's in time with them for his knee bend and his straightening-out also." [Laughs.]

A.S.: Is there any significance in the women's dance movement for the *werl*?

WÖMNDI: It is the same, to make their aprons and headdresses move together.

A.S.: Ongka once said that their action in rubbing their legs together imitated the act of swaying side to side in dodging arrows.

WÖMNDI: I don't know about that one! Maybe, but I've not heard of it.

A.S.: Forget it. Ongka also said that when men dance, they imitate the actions of birds of paradise in the forest. The bird sometimes molts, sometimes its plumage grows back, and when the plumage comes, it dances again.

WÖMNDI: Yes, that's true about birds, but I've given our main reason for dancing already; now, these birds don't come out of the bush to dance as we do, they just stay in the forest. Still, I can see what Ongka meant. The bird dances only when its plumage is fully grown, and we dance only when our pigs are fully grown and we are ready to make *moka*. I expect that was the comparison he was drawing. While the bird is young, it stays in the bush; that is like us when we go about our work and hide away from sight. And when it comes out to dance on a branch, that is like when we see that our pigs are big now and we come out to dance also, men and women together.

A.S.: What about the *kenan* dance and the one for the Female Spirit Cult, in both of which the men stamp the ground hard?

WÖMNDI: Yes, as with *kenan*, it is just so that people can see the feathers swaying in the headdresses, especially the Saxony feathers mounted on a spring. But for the Female Spirit, that is done so people will say that the goddess is in the earth and comes like an earthquake. The spectators yodel and the men hiss! The goddess is there, and she will make the men healthy and their crops prosper, their wives bear children and no one will die, we bring in the ritual experts to perform the spells for us, and we pay them as though it were bridewealth for the goddess herself.

Most of what I asked Wömndi here consisted of checking on matters that had already been analyzed earlier, and he graphically confirmed the themes I had thought important. His reaction to Ongka's model was quizzical and genuinely puzzled, as though the idea was quite unfamiliar to him. Then he saw its point and matched it with his own stress on the cycle of human work and display corresponding to a basic opposition between the private domestic world of production and the public political world of exchange.

Ongka's own account was given to me while I was taking part in a project that involved filming actual birds of paradise in 1978. He told me:

When the bird is young and its plumage has not yet grown, it just flies around feeding on fruits and drinking water, but when its crests [this is the King of Saxony bird] grow long, it realizes this and says to itself, "Ah, now my plumes have grown!" and so it goes to a display spot and there it dances. Before its plumes are grown, it will not display like this. It is in the same way that we people wear these plumes only when we are making a *moka*. At ordinary times, we keep them carefully wrapped up and hidden away, and that is like those times when the bird does not have its plumes. When we take them out and use them, that is like the time when the bird's plumes have grown. When the bird molts and its plumes fall off, it stops dancing and calling out, nor does it display itself. Later its plumes grow back and then it resumes the dance.

Ongka then went on to list the characteristic movements of all the birds of paradise in their various displays and to stress that the actions of the men in the dances are all like the actions of the birds, are in fact modeled on them.

Ongka's statements were remarkably concise yet evocative. He referred to two different kinds of cycles: one, the growth cycle of birds from youth to maturity, and two, the periodic molting and renewal of plumes that occurs during the bird's adult life span. These two are respectively paralleled in human life by the growth cycle of young boys as they become men and are able to take part in the dance, and the periodic nature of the *moka* ceremonies, marked by the growth and decline of the pig herds and stocks of valuables. The bird-of-paradise plumes, which are actually worn by men in dances, thus in themselves convey a statement about the nature of dancing and the life cycle that—in addition to their qualities of brightness, which were the focus of my earlier analysis of decorations—makes them especially suitable for such wear. At the same time, Ongka's model is not a standardized idea, since Wömndi was startled by it and had to adjust to it before seeing the point. It was almost as though Ongka were an anthropologist who had produced an analysis that accorded with the "deep structure" of ideas in Hagen culture and Wömndi a reader who was impressed by the analysis offered!

One crucial aspect revealed by Ongka is the connection between birds as symbols of sexual attraction and birds as markers of generational growth and decay, such as the cassowary in the Umeda *ida* ritual. Another aspect of the cyclical movement of generations was shown

to me when I investigated facial designs among the Wiru during visits in April and August of 1980 as well as during an earlier trip in September 1978. In 1967, when I first worked in the area, I had taken a number of color photographs of decorated men, women, and girls, and I brought back color prints of a selection of these to work from, enlisting the help of an old informant, Longai, and a younger man, Unuka. Longai proved very precise and enthusiastic, yet it was Unuka who in the end provided the key to the whole operation. During the first fieldwork in 1967 I had no idea of the meaning of facial decoration; indeed, we had not yet systematically worked over our Hagen data. However, the old photographs provided a useful starting point, and it soon emerged that the code of face painting in Wiru is markedly different from that in Hagen. In Melpa usage, particular designs executed on a part of the face have conventional names, but the overall design does not. It is the colors themselves that carry the load of meaning, together with the stress on making the recognition of men as difficult as possible. However, in Wiru usage, each face design is given an overall standard name, and the great majority of these are the names of birds—not just birds of paradise, although these are included, but many kinds of small, ordinary birds as well. The designs may also be named after shield decorations, pearl shells, or the sugar-glider, a type of marsupial that also flies like a bird. The semantics of this naming process are complicated by the fact that men may combine features from more than one bird, in which case the composite design has to be broken down into its different parts. There is also some variability in the ways in which the designs themselves are executed, both factors giving scope for imagination and personal choice. There are probably some twenty bird names regularly used, but not all observers automatically agree which is supposed to be represented in a particular composition. The final test is always to ask the dancer himself, to find out what *wene*, or intention, he had in applying his face paint.

These designs are not totemic, nor do they have a direct magical purpose any more than the Hageners can be said to have one in wearing bird-of-paradise plumes (which the Wiru also wear). My own first guess was that the designs function to individuate the men as whole persons one from another, since in a row of men so decorated each may be identified by his face design with a different bird or other object. There is some merit in this guess, but it needs to be amplified by the more definite explanations offered by Unuka:

Men do not make up these designs by themselves. These are all taken from the "pictures" of birds and their markings, just as we take the markings of snakes and put these onto our bark belts. . . . When birds are born, they do not have these decorations, it is only when they grow up that they develop them, so they have these decorations as the successors to their parents, who had them before. Birds do not imitate others, it is we who imitate them. Birds follow their own line of descent, the next generation reproduces the markings of the former and nothing else, so they are handed down, and we follow them.

Unuka's model shows definite similarities to Ongka's, but without the notion of the periodicity of the ceremonies themselves that Ongka has built into his. Instead, Unuka stresses the growth cycle and goes on to emphasize how birds "breed true," transmitting their markings over the generations. Men, in using such birds as the prototypes for their face-paint designs, are therefore asserting a similar continuity for themselves, which is consistent with another Wiru practice not found in Hagen: the transmission of particular names within small lineages of men. The choice of design does individuate in practice, then; but as a cultural model, it also asserts continuity and conformity.

These two cases of bird analogies among the Melpa and the Wiru follow closely from the discussions of the meaning of phallic imagery and gender differentiation in Umeda and Abelam. Themes that are similar on one level also carry particular connotations in particular societies, and we may need the help of the informants' own insights to guide us in seeking out these variant meanings. The same is likely to be true, for example, in the study of the significance of hair and wigs, which are so prominent and undoubtedly have magico-religious significance in Highlands cultures, from the Huli in the Southern Highlands to the Gahuku-Gama around Goroka in the Eastern Highlands. I shall use this example of wigs as a final means of contrasting New Guinean customs with contemporary western practices of self-decoration, specifically focusing on women's cosmetics, which I briefly mentioned earlier.

Why do Highlanders wear wigs? For the same reasons that wigs are worn in Britain, say? This seems to me unlikely. For one thing, wigs are characteristically worn by men in New Guinea, both as an everyday item and for ceremonial wear, when special wigs are constructed. Particular wigs may differentiate bachelor initiates from older married men, as among the Huli, where—in Robert Glasse's description—bachelors "emerge from their confinement wearing the red, crescent-shaped ceremonial wig that symbolizes manhood. Dressed in their finest feathers, shells, and possum skins, they paint their face in traditional patterns with red and yellow clay [from photographs, these look like Wiru designs] and their bodies glisten with oil.... Each carries a strung bow in one hand and an arrow in the other. Men who see them praise their appearance; from a distance women strain to catch a glimpse of them."[8] In the Wahgi Valley area, the special long wigs are connected with both sexual attractiveness and, more fundamentally, with fertility. To ensure that the wigs are bright, payments have to be made to relatives of the wearer's mother, the sources of female fertility; correlatively, the men should rigidly avoid any relations with their traditional enemies and cultivate good feelings for and with their own clansmen, according to Michael O'Hanlon's unpublished 1980 field report. In Hagen, the most characteristic wig is the "Enga head," or *peng lepa*, constructed—like the others—from human hair and shaped into two long horns that form a downturned crescent. The wig must be dark, and ancestral ghosts are expected to lodge in it and help the wearer when he dances. Such wigs have therefore sometimes been constructed inside clan cemeteries. All of these instances, then, show specific religious and symbolic traits associated with men's wigs—sexuality, fertility, ancestral support—and all of

these can indeed be seen to belong generally in the complex of ideas about the significance of head hair to which anthropologists have often drawn attention. What is of interest is that in the Highlands all the emphasis is on *men's* wigs, whereas in western society today there is surely much greater emphasis on wigs worn by women, which exist *only* for the sake of individual attractiveness and not as markers of status as such. It is the same, as I have noted earlier, with cosmetics today. In New Guinea, both sexes decorate themselves and wear face paints; in western society, makeup—outside the contexts of drama and filmmaking—is largely the prerogative of the female. Western men are reduced to the role of the *kawanugwi*, the preceptor in Umeda ritual, who is the only one not to wear face paint. Why? It is surely because of the specialization of women as sexual objects, which now offends feminists in western society as much as it continues to delight and satisfy male chauvinists.

But, as I have already hinted, there is also another factor: the whole concept of the person is differently perceived in western society from the way it is traditionally regarded in New Guinea. What is at stake here, as Marilyn Strathern has pointed out in her paper "The Self in Self-Decoration,"[9] is the dichotomy between mind and body that has developed in western thought and society. John Blacking, in his introduction to the book *The Anthropology of the Body*, has pointed to the same problem:

> The pathological mind/body dichotomy is also reflected in contradictory cultural conceptualizations of physical experience. For instance, "falling in love" and "being in love" are usually distinguished from "having sex" as higher forms of an essentially animal activity.[10]

Women as sexual objects are seen as the focus of this "animal desire," and are then dignified in terms of the ideology of love. The western restrictions on face painting so that it is employed only by women reflects these two facets, since men are not seen as objects in at all the same way. But in Hagen, for instance, the ideas of the body, the person, and the individual are all distinctively organized in ways that avoid this particular form of dichotomy. It is true that a distinction is made between the *noman*, or mind, and the *king*, or body, but the two interact in an intimate symbiosis, and the welfare of both is dependent on proper actions within a nexus of kinship relations. The person, as a union of *noman* and *king*, is never isolated from the social network, and although there is a lively stress on individual autonomy and decision making, the person as a whole is always thought to be an expression of social forces. The paradox therefore is that while gender differentiation in general may appear much more obvious and inequality of the sexes much more marked in Hagen than in western society, it is nonetheless in the matter of self-decoration and the body that the west is the more unbalanced. In Hagen, both sexes decorate themselves and celebrate their social ties, as well as their attractiveness to others; in western society, the cosmetic act has become a technology especially limited to the image of women as objects of male desire, thereby contributing to the analogy between the categories of male/female and subject/object within

the society. Thus, if we look at other peoples' practices of self-decoration and face painting through the lenses of our own dichotomies, then we shall certainly not understand such customs properly, but a proper understanding of what these decorations mean in New Guinea may well provide guidelines that will help us analyze our own situation.

Let me try to develop this point a little further. It is much harder for me to do this than to discuss the details of New Guinea art and decoration, but it is important to look at the phenomena cross-culturally, and this means moving backward and forward over cultural boundaries. Consider Marilyn Strathern's point that "the process of beautification . . . may actually detract from individuality. . . . The skin, the outer surface, is in this context truly superficial, trivial in relation to personal identity." According to this argument, cosmetics produce a kind of stereotyping; the individual as an entity is assimilated into an ideal of beauty, and is thus not enhanced but replaced by this ideal. This is analogous to the Hagen *men's* act of disguising themselves by their face painting, and the analogy holds also to the extent that in both cases the disguise is not meant to be truly effective, so that we are therefore not dealing with a straightforward case of "the mask." But there are two crucial differences. The first is that for western society we are talking about women, and men, notionally at least, do not use cosmetics in this way. The second, equally important difference is that makeup is an ordinary, everyday, practically obligatory item for women in this western society, whereas it is situational and special for both sexes in Mount Hagen and New Guinea generally. This explains why the issue of whether women should pluck their eyebrows and wear makeup was the subject of much controversial debate during 1979 in Papua New Guinea's national newspaper. The thought of Mount Hagen women—and not men—going about their daily business with face paint on is culturally nonsensical: it is unthinkable for them. And yet it is we who think of the people of New Guinea as practicing face painting or body painting and consider this exotic! Seen from a Mount Hagen viewpoint, our assumption that women and not men, should walk around all the time with cosmetics on is the practice that is exotic and in need of explanation.

An attempt to formulate that explanation has to take into account the idea that we are dealing here with a double-layered phenomenon within which there may be contradictory messages. Makeup enhances individual attractiveness, yet it also stereotypes the individual, and it is especially women to whom the paradox applies. Why? The double character of the female gender, as both subject and object in a sexual context, underlies the paradox. The operative phrase in western culture seems to be "I must put my face on," since "face" refers both to an aspect of the self as individual and to the self as a stereotyped image that must be presented to others in the correct way. Insofar as "skin" and "face" are then considered synonymous, we arrive at the point of the mind/body dichotomy once more, since face is an aspect of the body, as opposed to the mind, in our symbol system. Why, then, don't men also put on cosmetics every day? (They are, of course, allowed after-shave, but anything that smells too much is regarded as inappropriate.) The answer is that men are not seen as ambivalent subject/object creatures, but rather are presented as subjects, who establish their

identity through their acts rather than simply through being looked at and admired. They gain prestige from doing rather than being, and it is an aspect of the created "being" that cosmetics celebrate. That things are, however, rather more complicated than this in practice, and that women's actions in dressing and the use of cosmetics can also be seen as the deliberate acts of subjects, can be guessed from a controversy in Britain surrounding Anna Ford, a prominent television personality. Ms. Ford rightly objected to newspapermen who concentrated in their accounts of a public meeting that had to do with the position of women in society on photographs of her split skirt rather than on what she said. A possible ambiguity in the dispute was pointed out by a letter writer to the *Guardian* when he asked why Ms. Ford had worn the skirt at all if she indeed had not wished to attract that kind of attention. In effect, unspoken male appreciation of the skirt might have disposed male listeners to praise what the speaker had to say, but public acknowledgment of this element instead shifted the primary focus to consideration of Ms. Ford as a decorative object, and this made further *serious* considerations of the issues she was raising impossible. My intention here is not really to comment on the actual dispute but to indicate that its basis lies in the symbolic value of the body as opposed to the mind in our culture. The form of dress announces, "I am a woman" and this is *opposed to* the other message, "I am a person who can speak on an intellectual topic of public interest, such as what it is to be a woman." Generalizing, we may say that the model of "woman" here is that of the "culturally modified natural object," while that of "man" is the "naturally active cultural subject." Since this particular—if not peculiar—interplay of ideas about nature and culture does not form a part of Hagen ideas about the sexes, it is obvious that we could not use these categories to discuss the construction of gender perception and interaction in Hagen society. The sexes are certainly sharply distinguished, and are separated by taboos that have no currency in the west; there is also an ideology of male superiority vis-à-vis women, but this does not extend to requiring women to carry the whole "load" of artifice and sexuality, as is the case in the western cosmetics tradition. In this sense, it is wrong simply to equate New Guinea self-decoration with western forms of cosmetics because the underlying ideas that it expresses are rather different. For as in Wömndi's explanation, it is the transformation of the private into the public that is sought, a transformation through which the "mind" of the practitioners is judged by the condition of their decorations and the adorned "skin" that in turn supports them, just as the ground supports and nurtures the people who live on it.

· 39

NOTES

1. John Scofield, "Australian New Guinea," *National Geographic* 121, no. 5 (May 1962): 614.

2. Irving and Electa Johnson, "New Guinea to Bali in *Yankee*," *National Geographic* 116, no. 6 (December 1959): 773, 776

3. Alfred Gell. *Metamorphosis of the Cassowaries.* London School of Economics Monographs on Social Anthropology. London: Athlone Press, 1975.

4. Anthony Forge, "Art and Environment in the Sepik," *Proceedings of the Royal Anthropological Institute,* 1965, p. 25.

5. Andrew Strathern and Marilyn Strathern. *Self-Decoration in Mount Hagen.* Toronto: University of Toronto Press, 1971.

6. Ron Brunton, "Misconstrued Order in Melanesian Religion," *Man* 15, no. 1 (1980): 113, 118.

7. James C. Faris. *Nuba Personal Art.* Toronto: University of Toronto Press, 1972.

8. P. Lawrence and M. J. Meggitt, eds. *Gods, Ghosts, and Men in Melanesia.* New York and London: Oxford University Press, 1965.

9. Marilyn Strathern, "The Self in Self-Decoration," *Oceania* 48 (1979): 241-57.

10. John Blacking, ed. *The Anthropology of the Body.* New York and London: Academic Press, 1978.

FACES

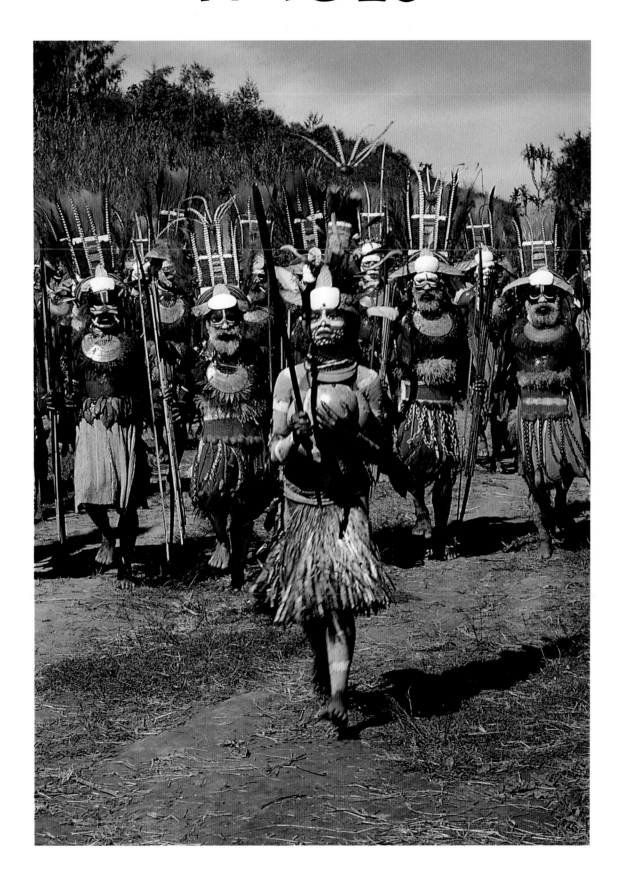

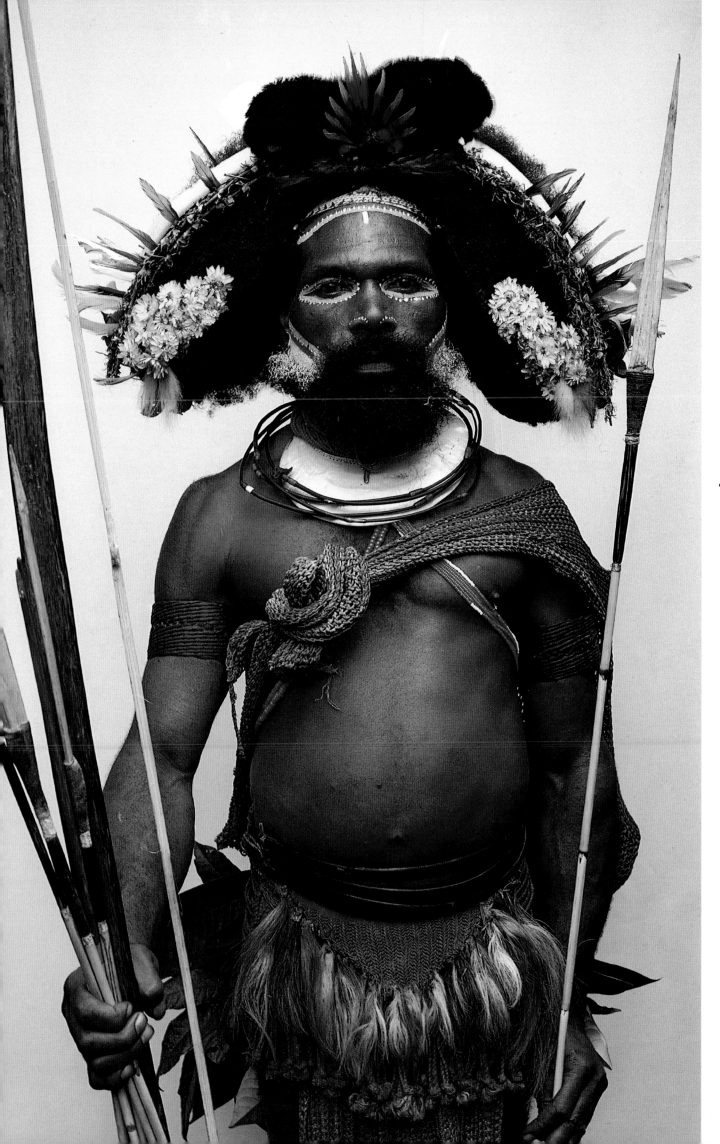

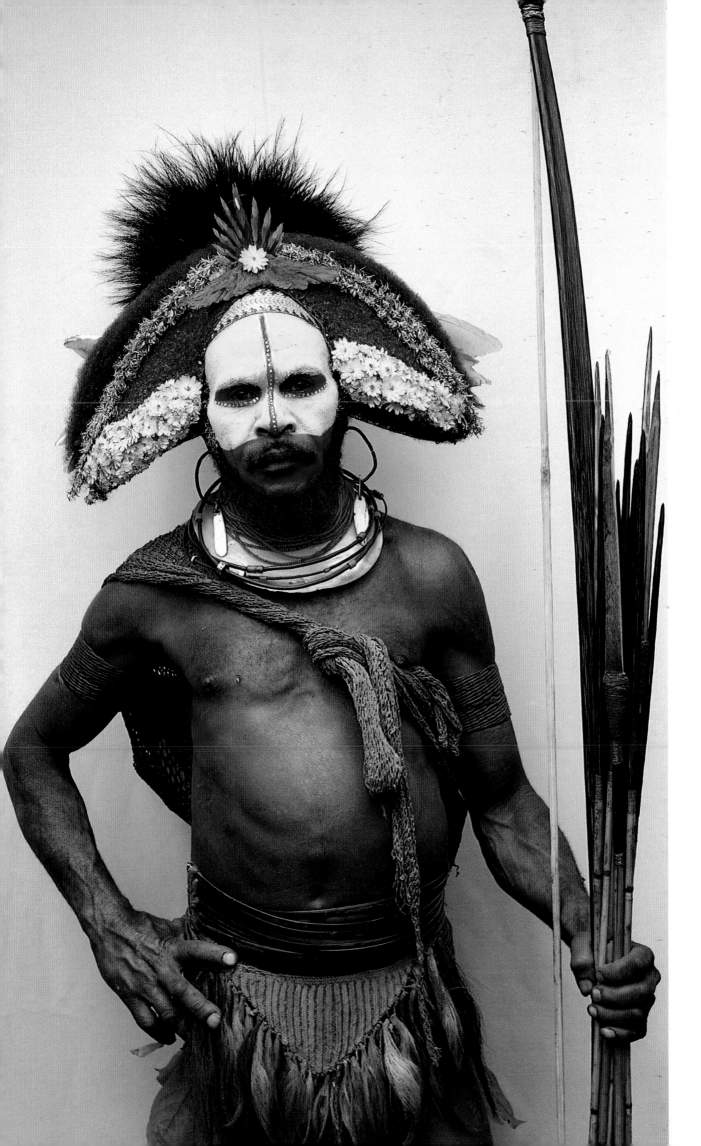

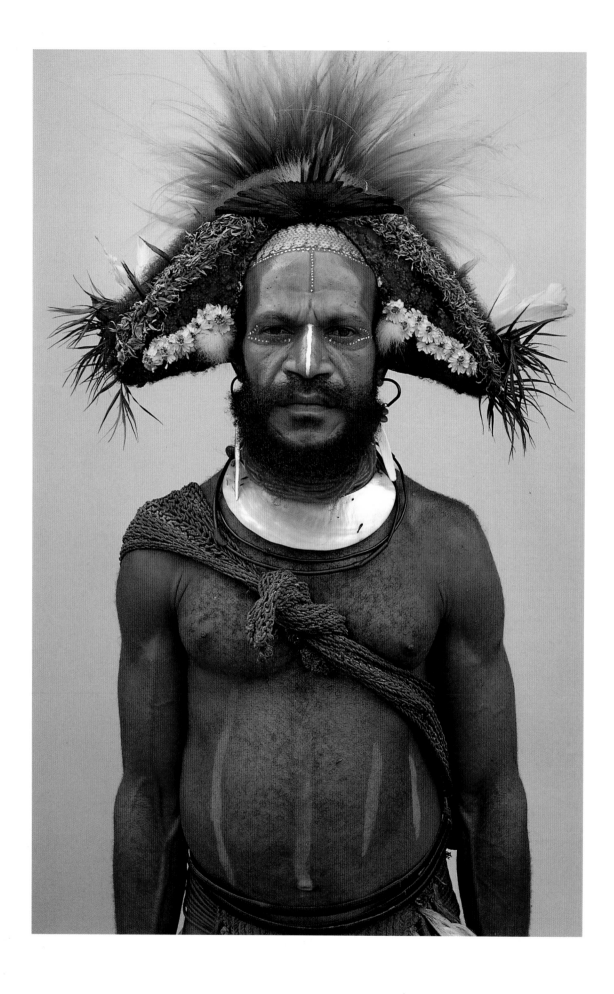

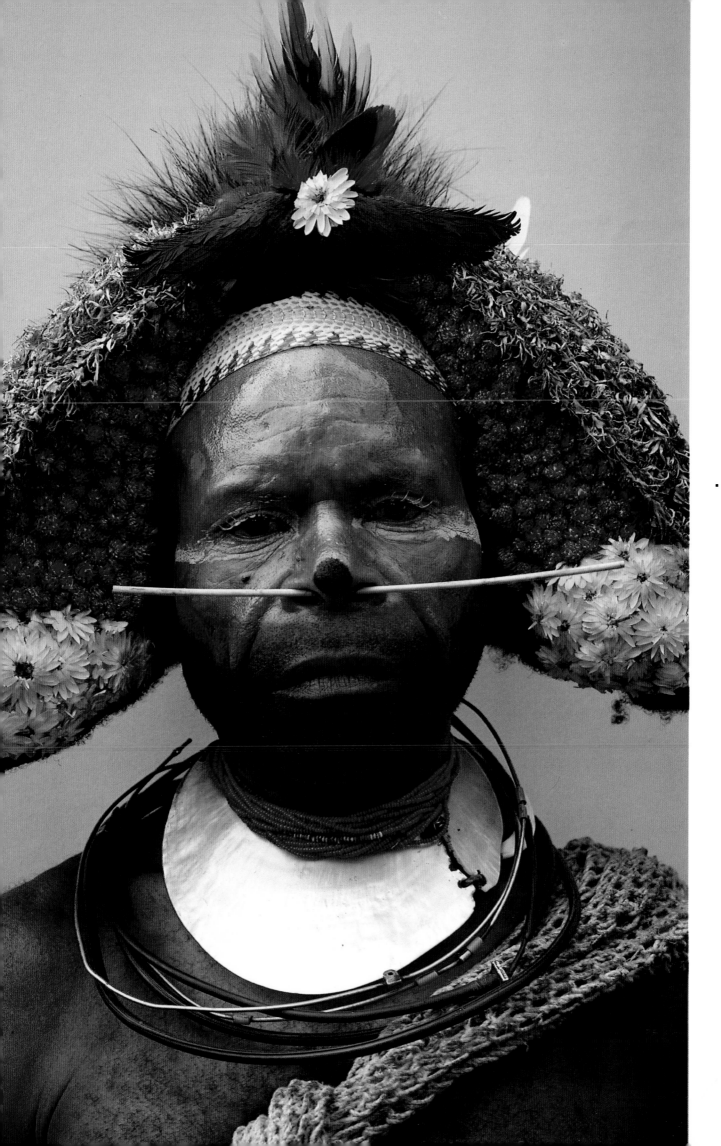

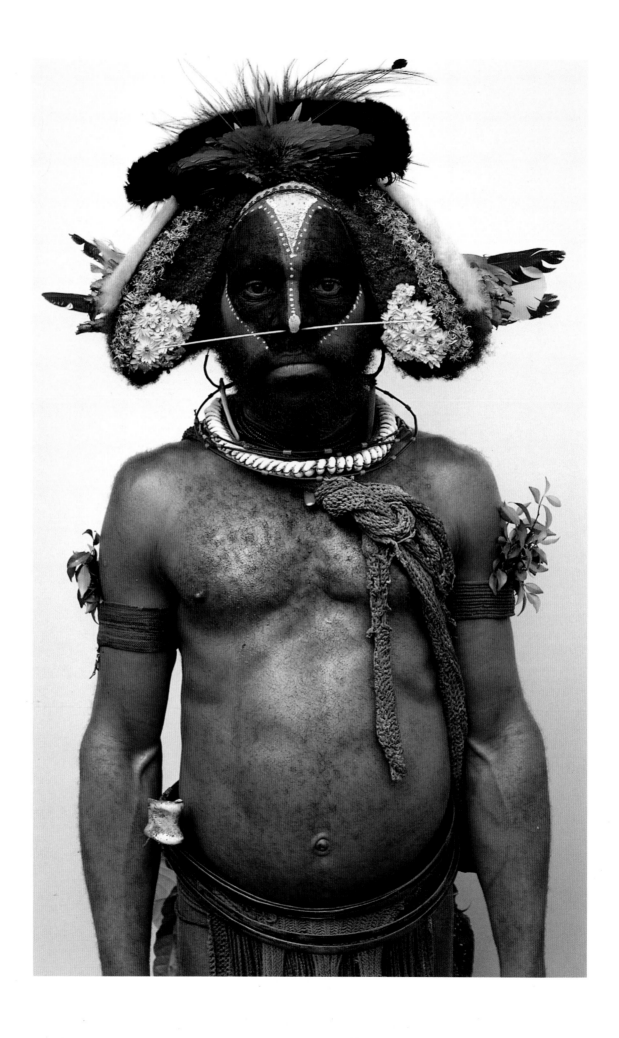

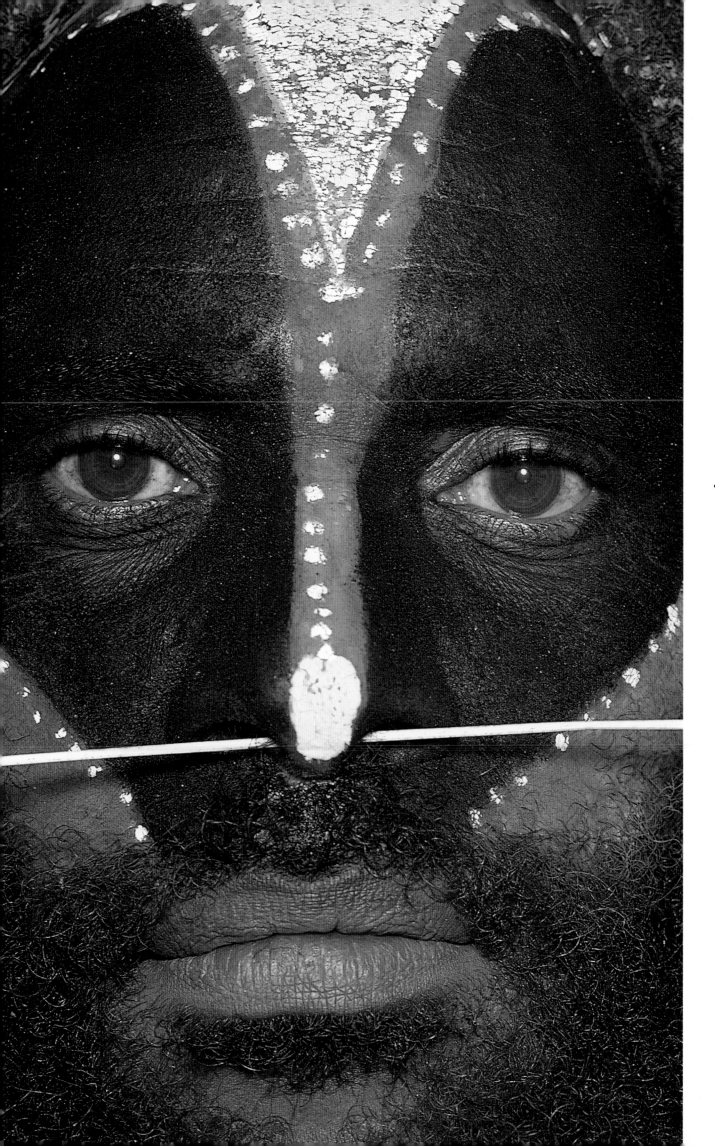

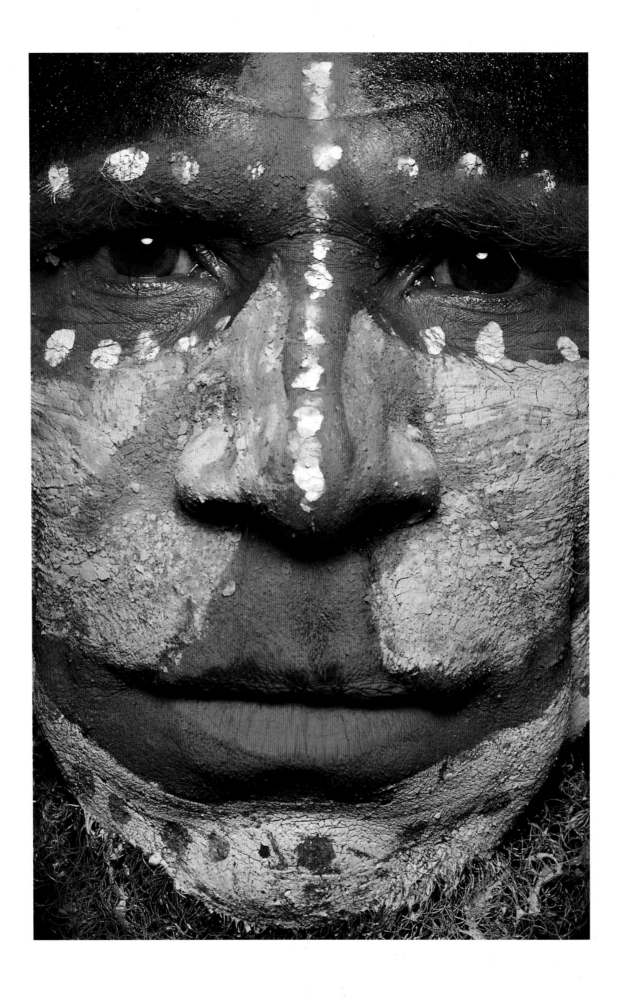

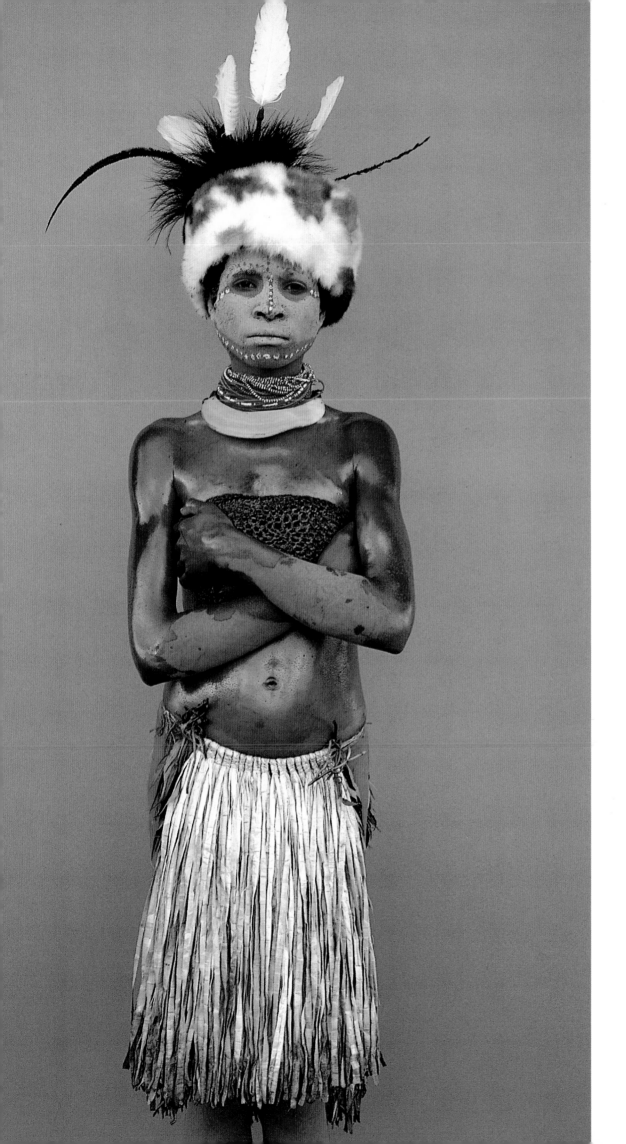

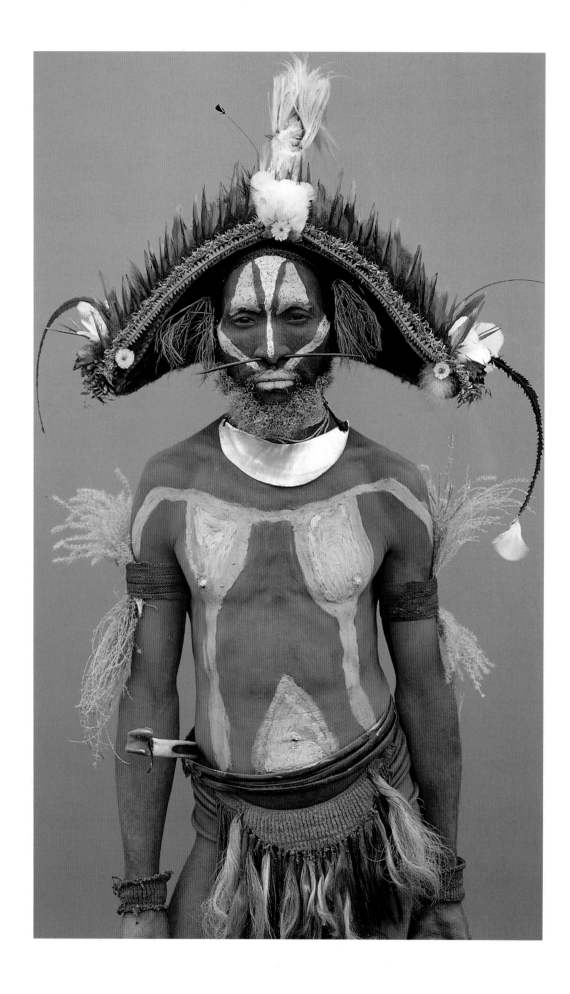

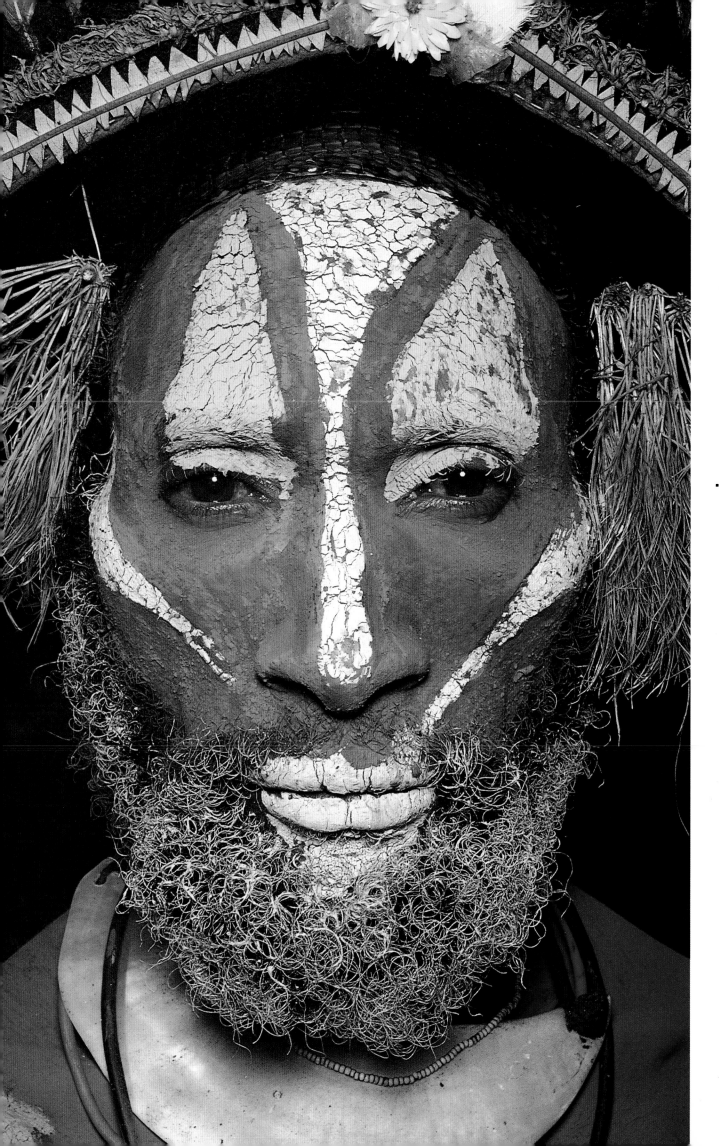

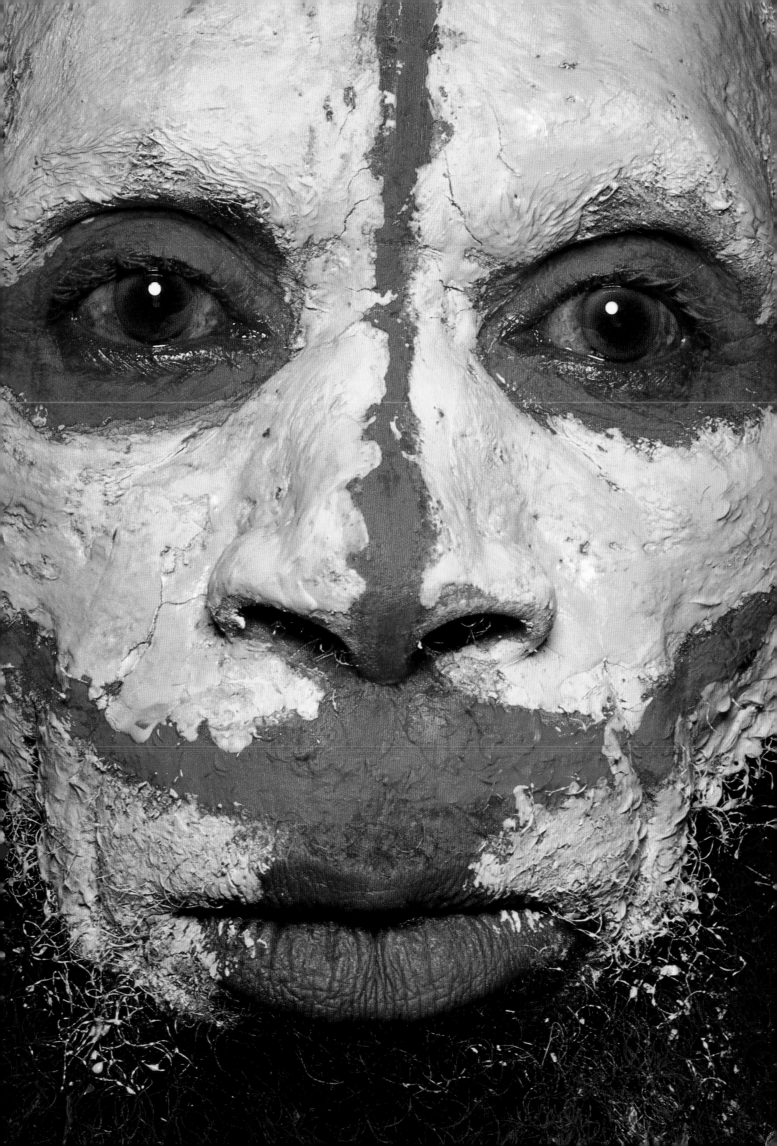

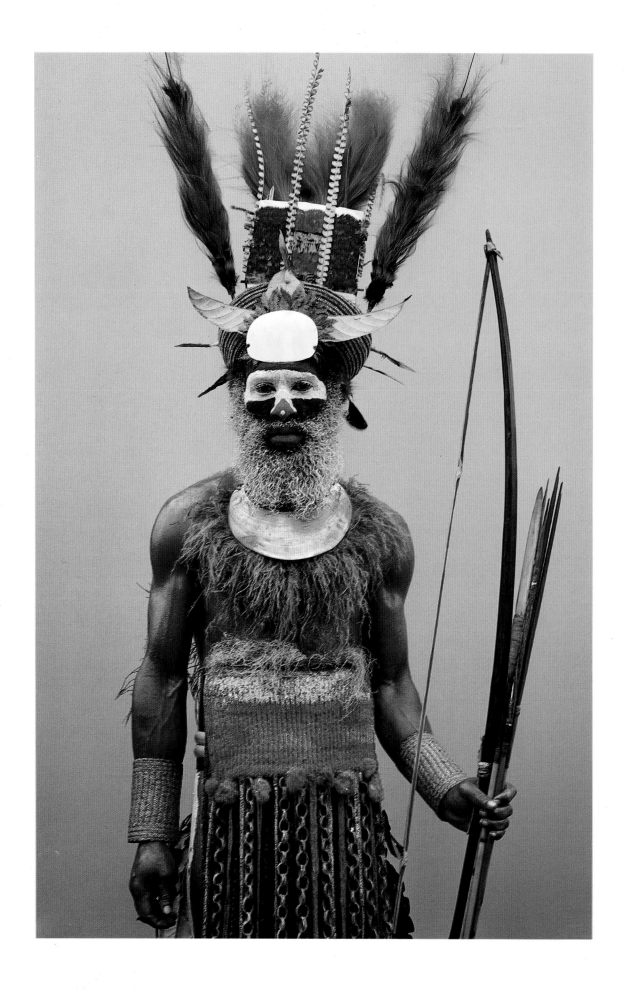

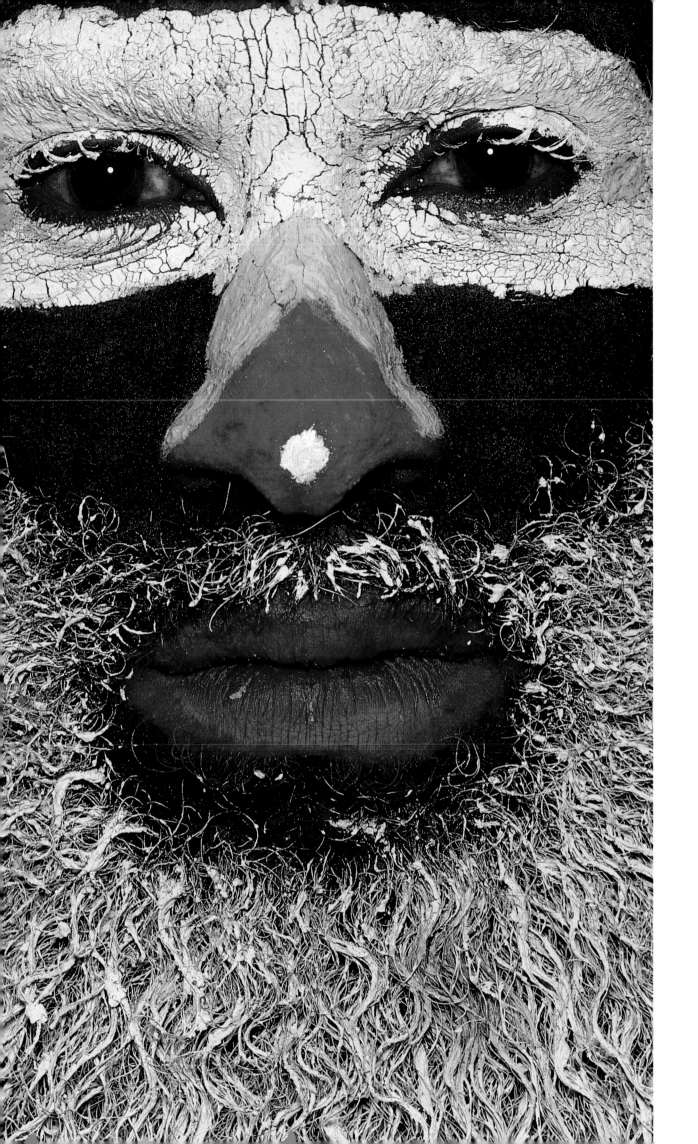

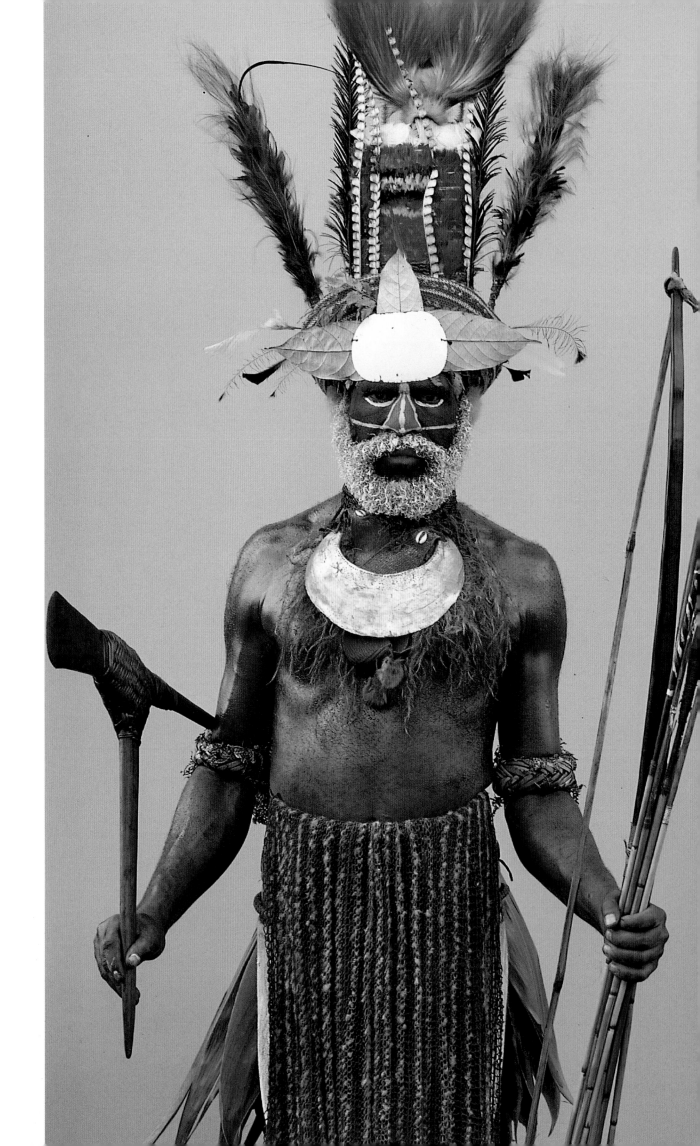

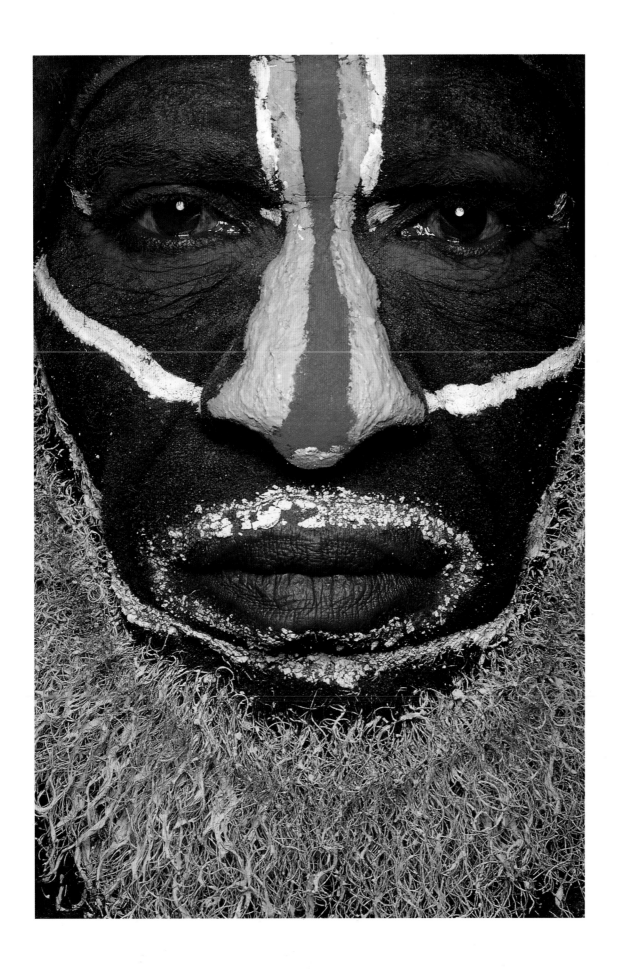

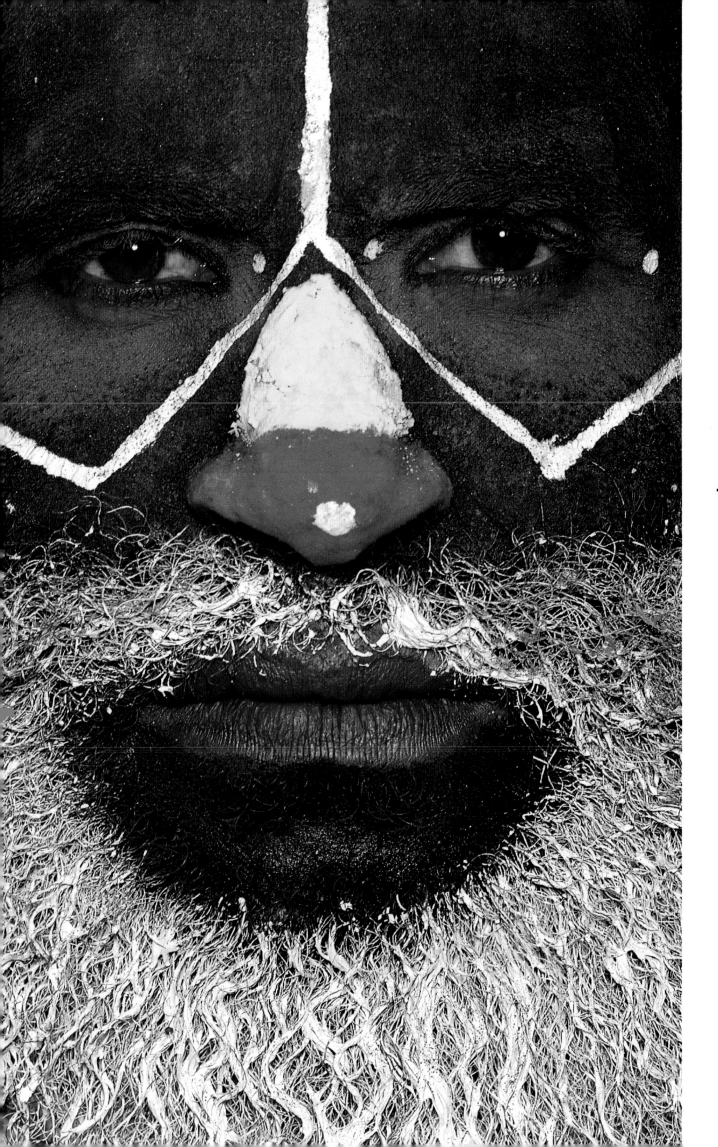

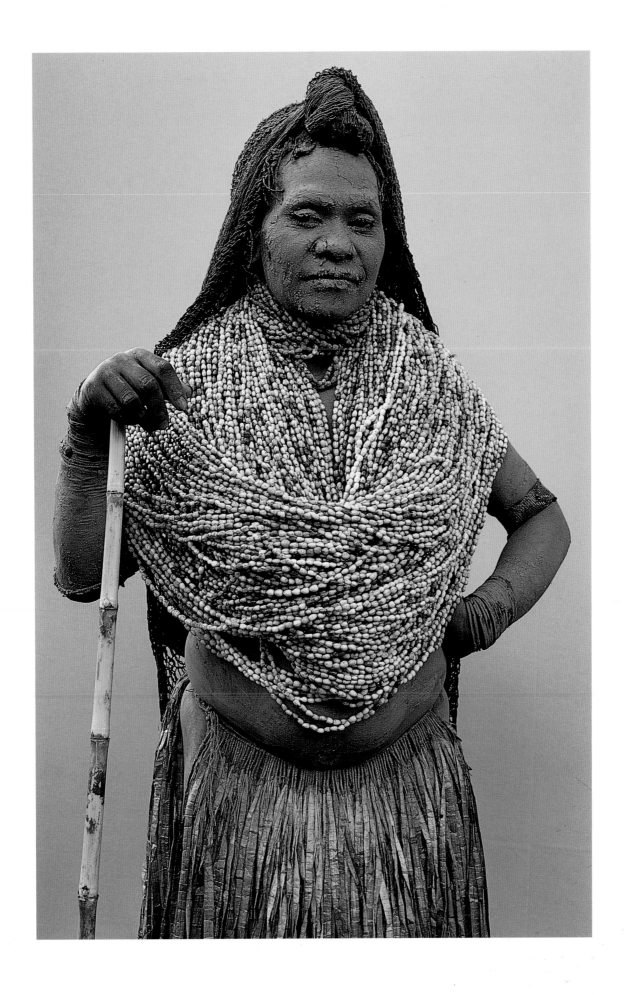

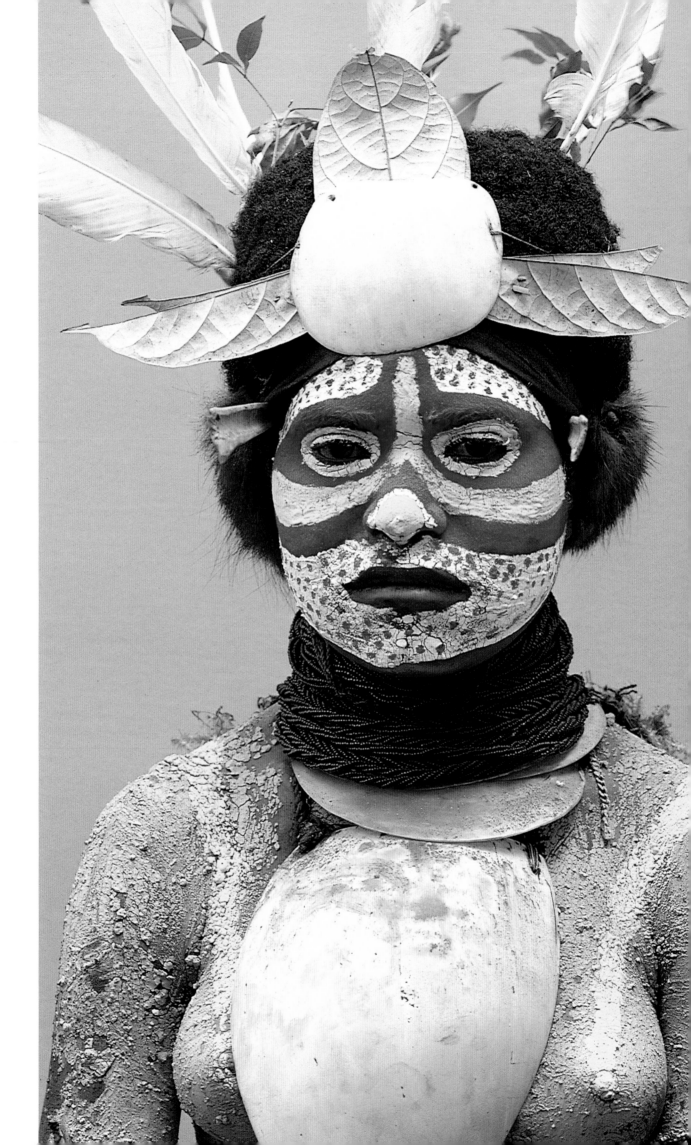

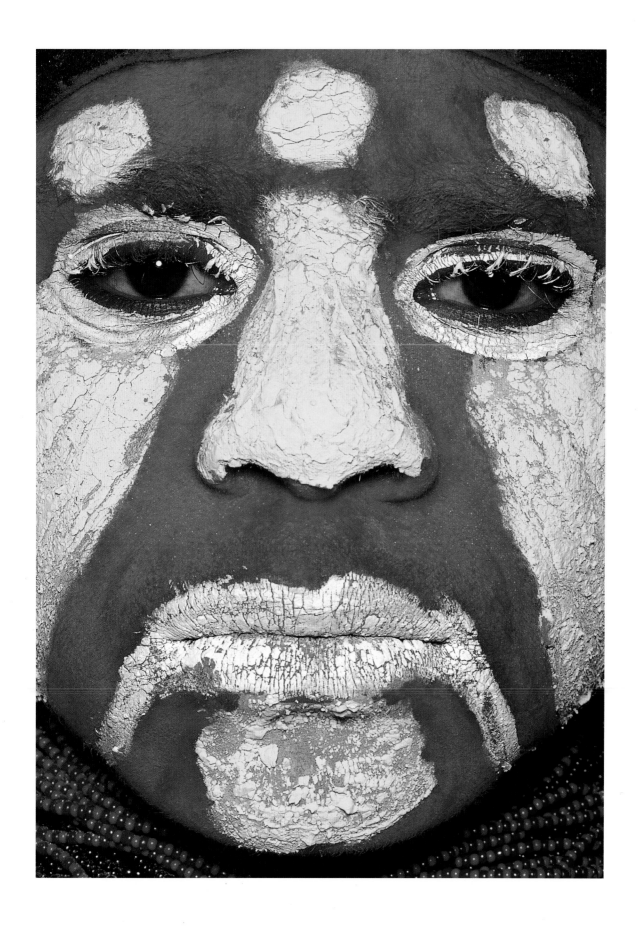

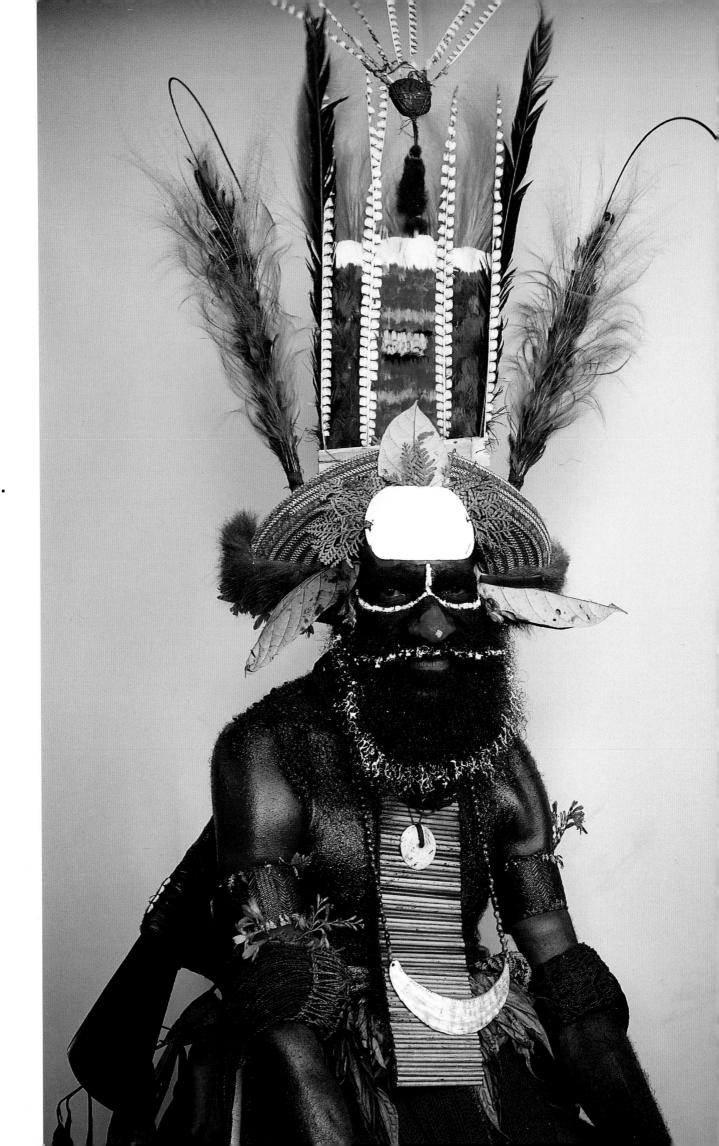

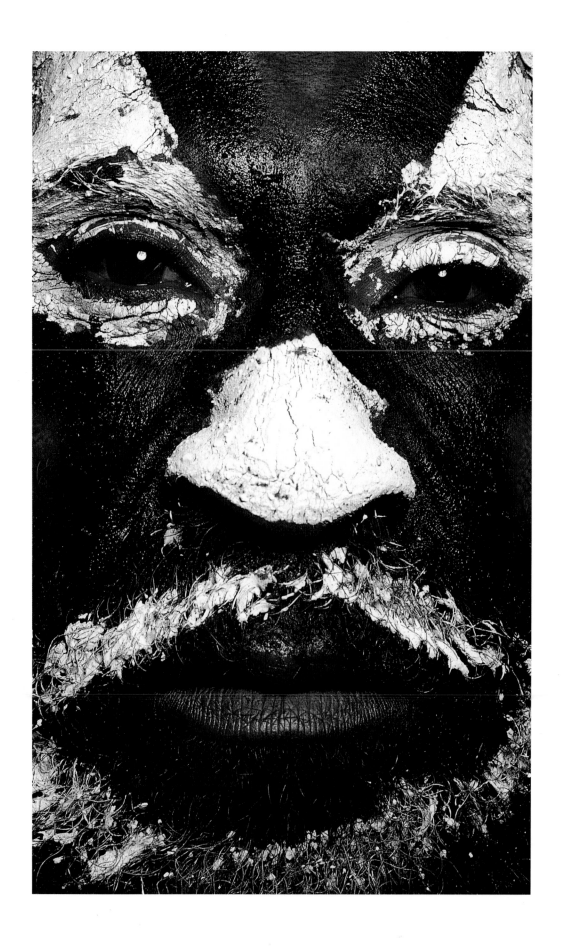

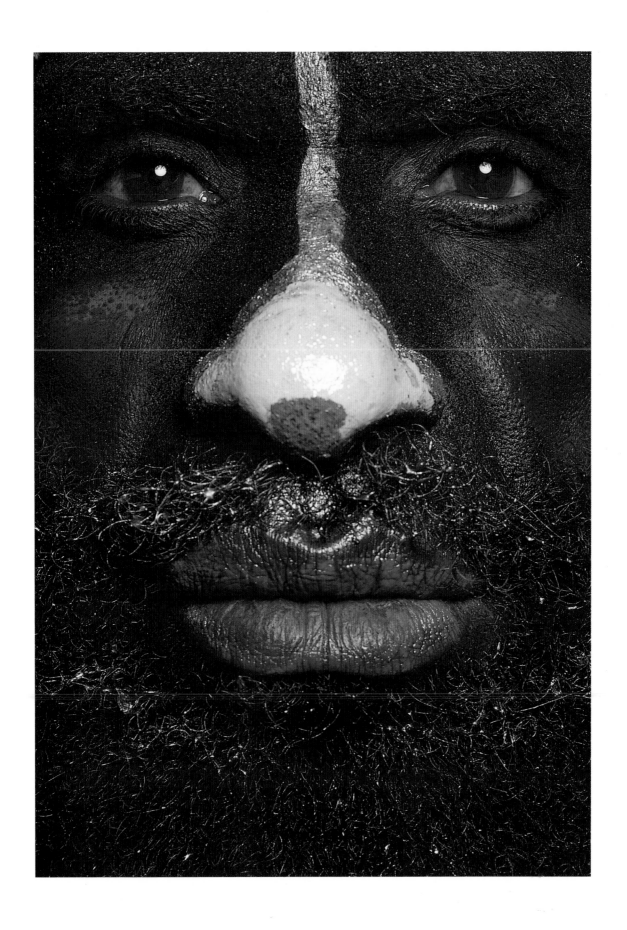

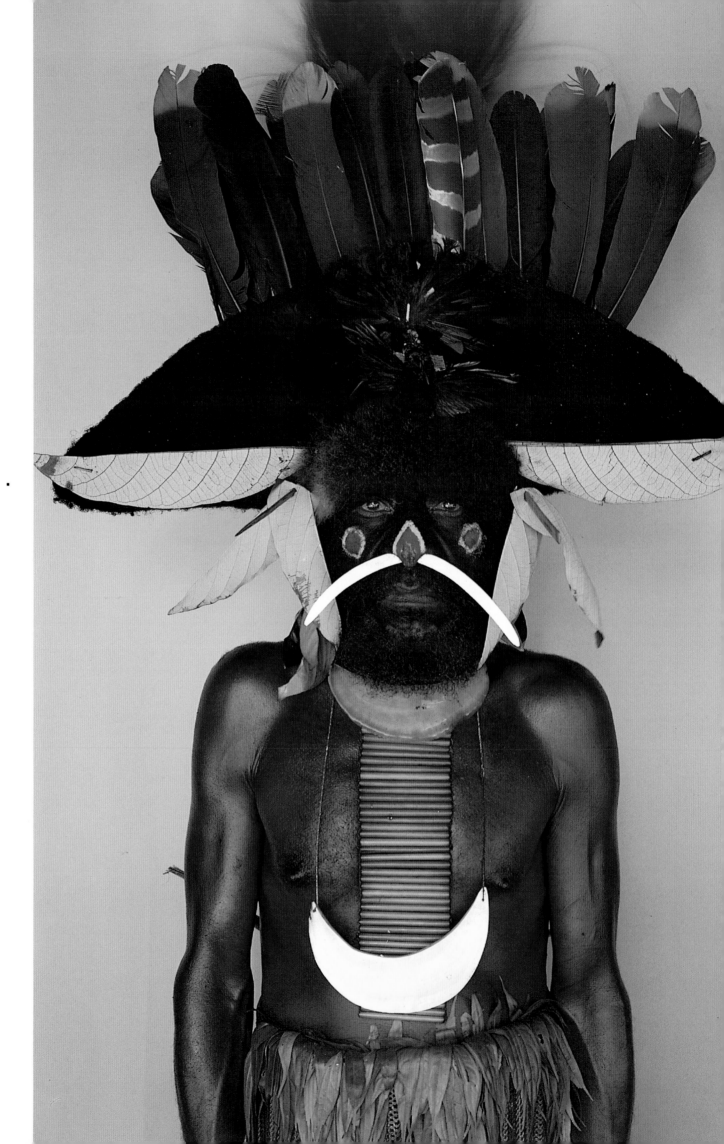

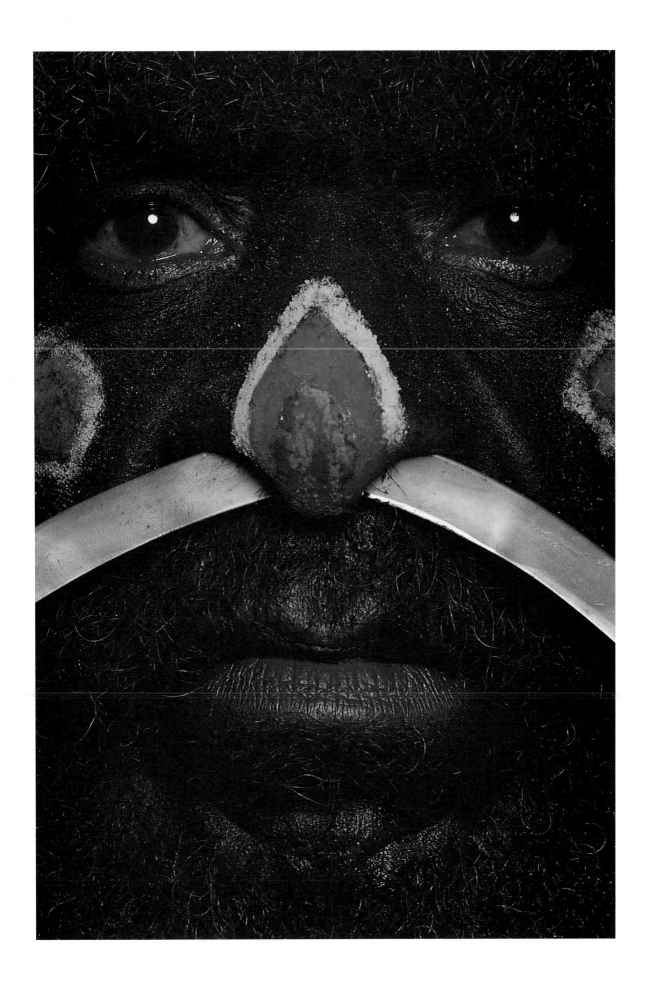

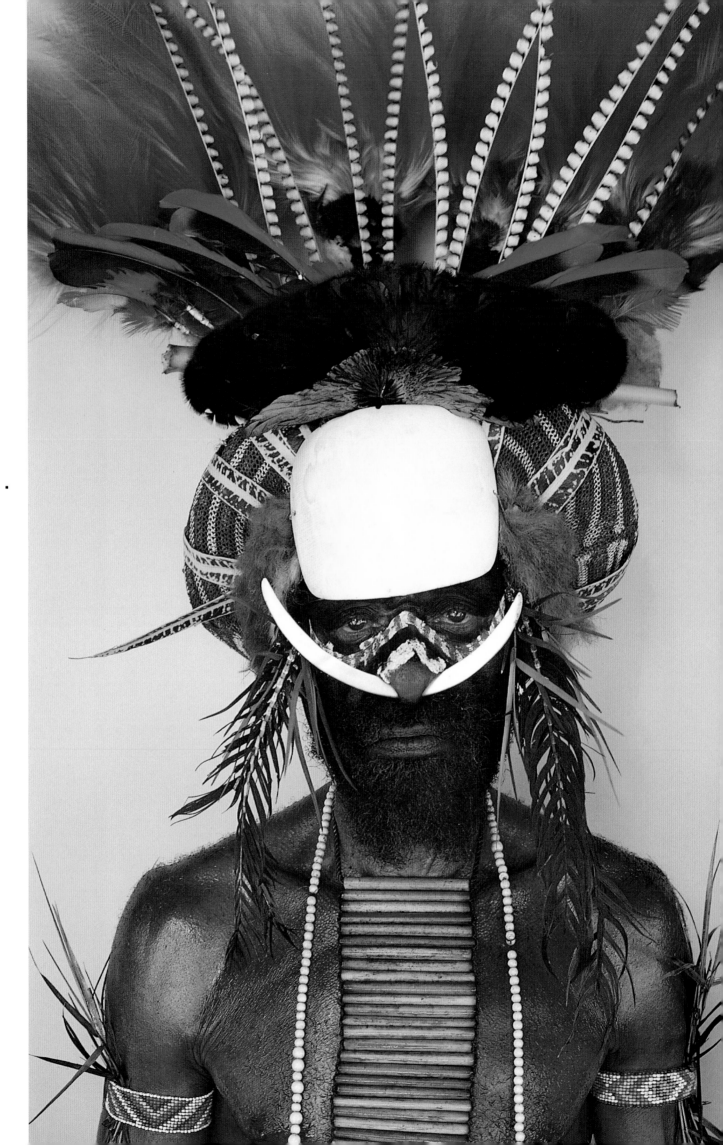

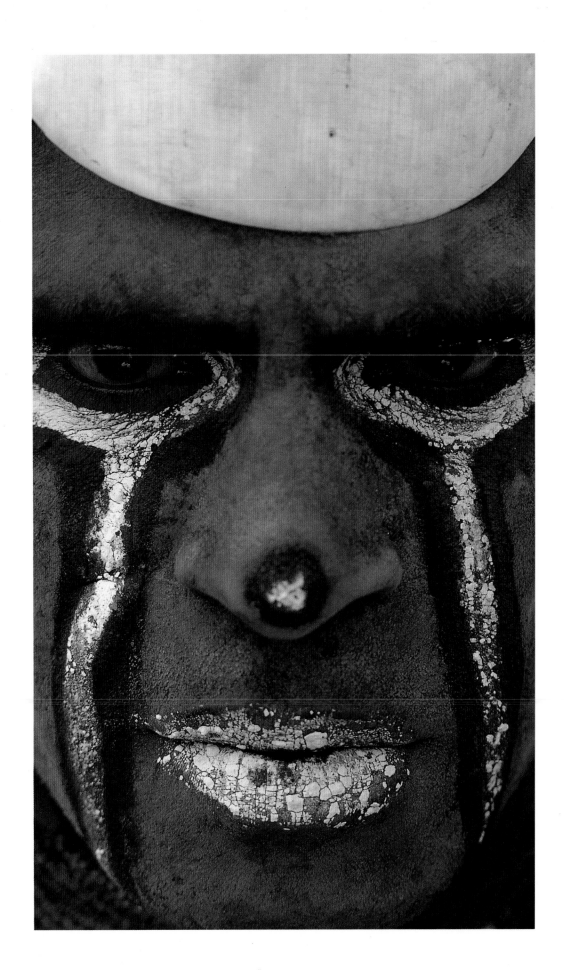

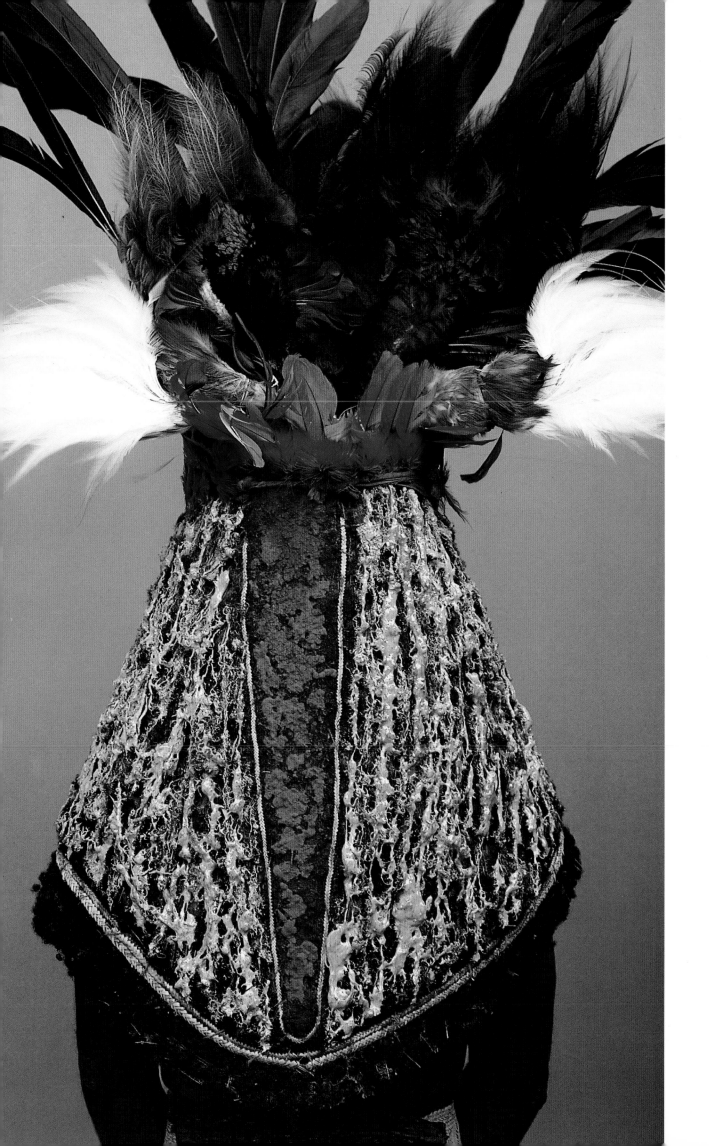

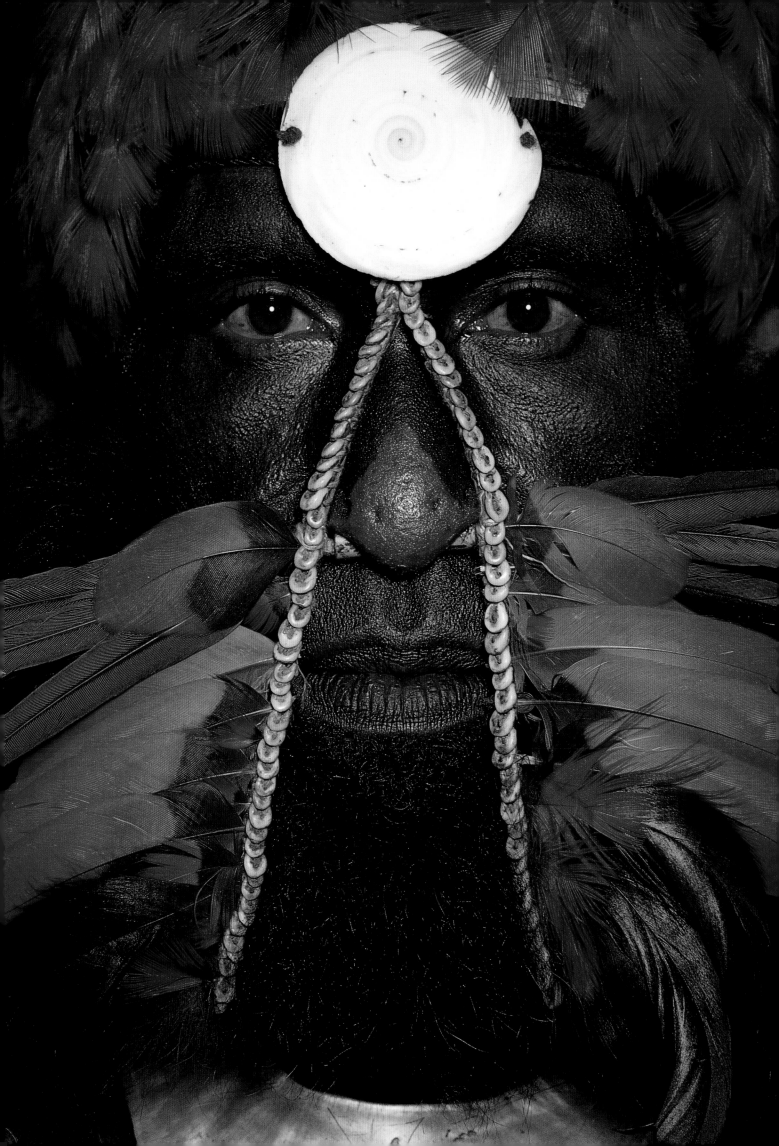

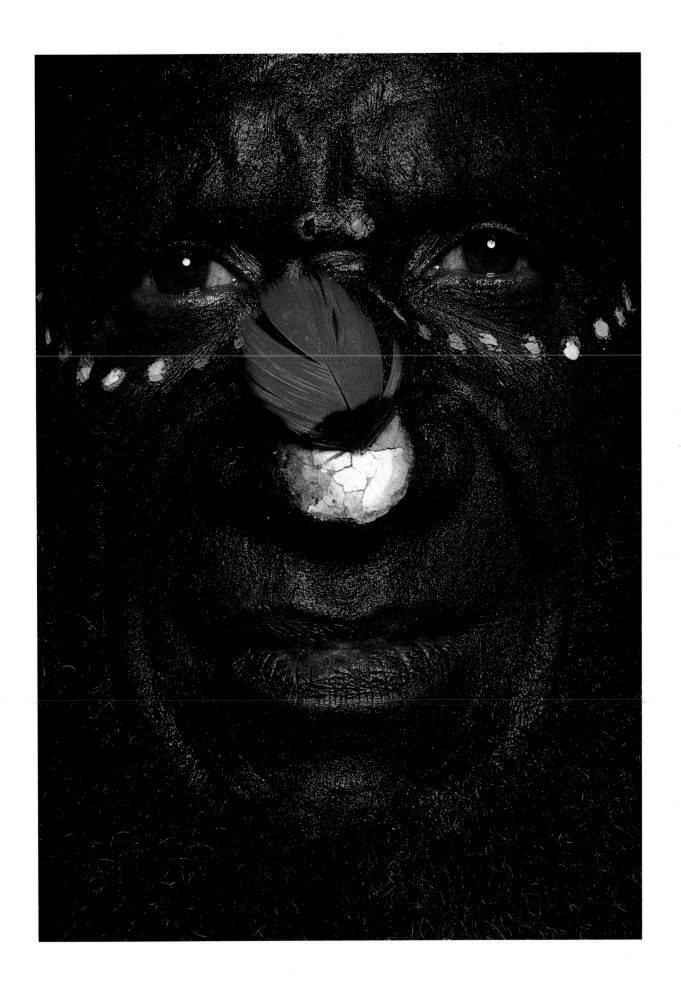

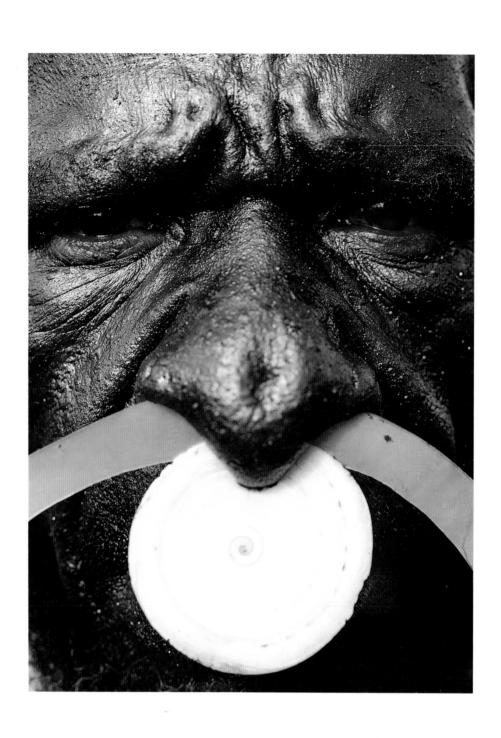

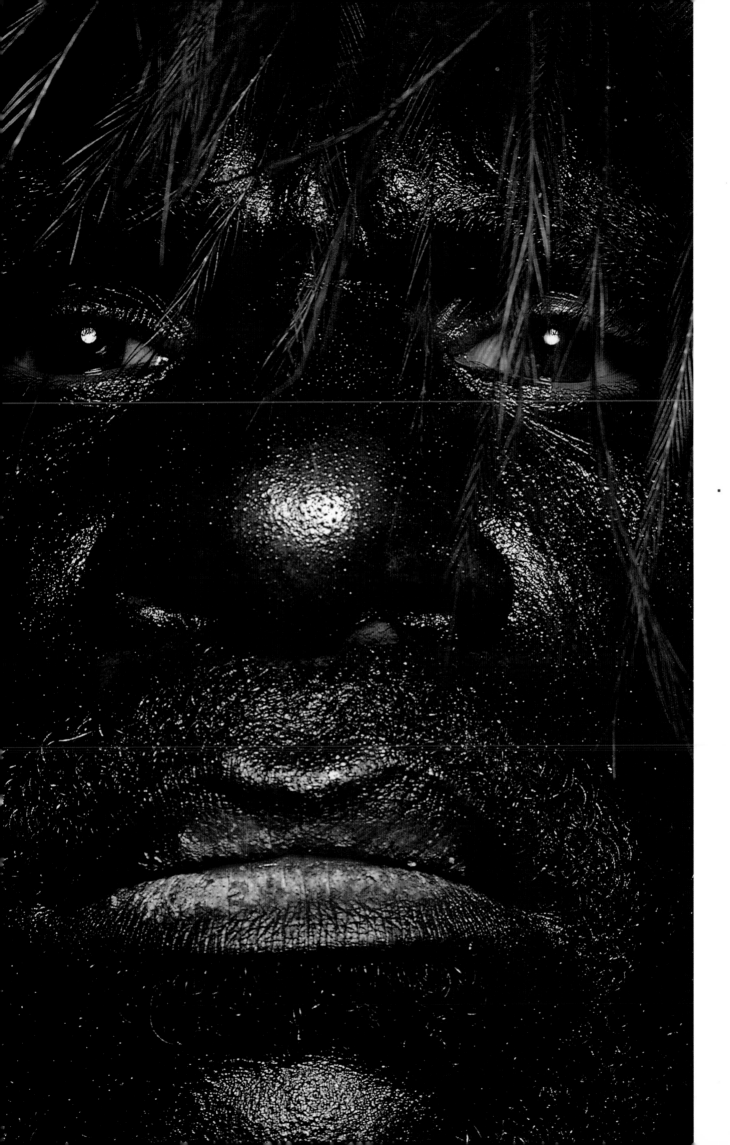

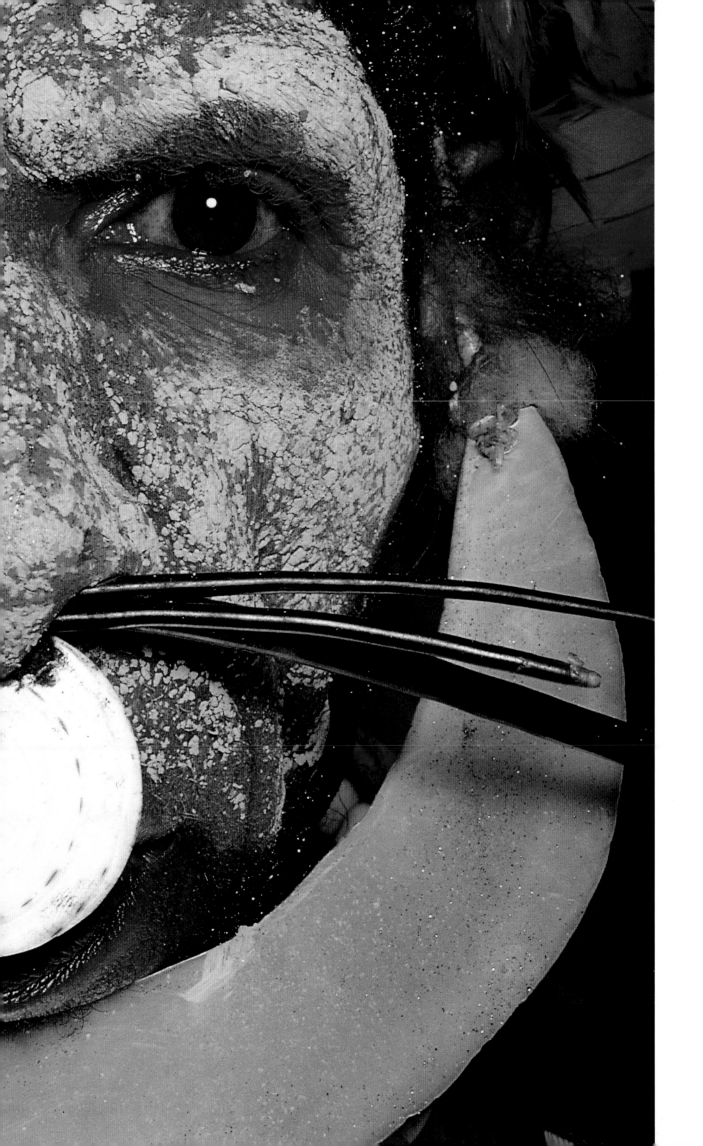

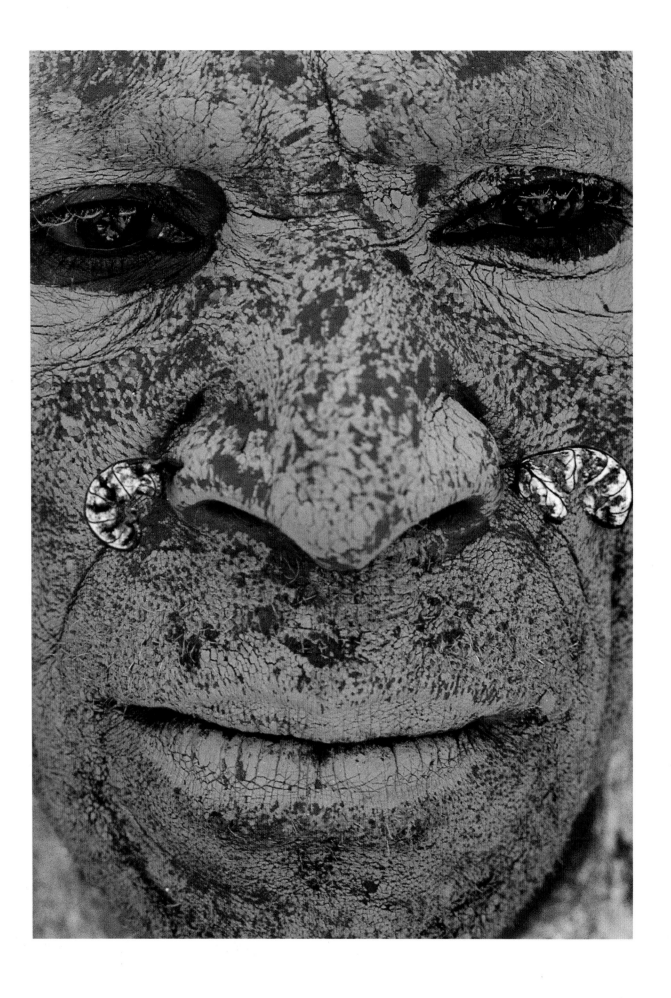

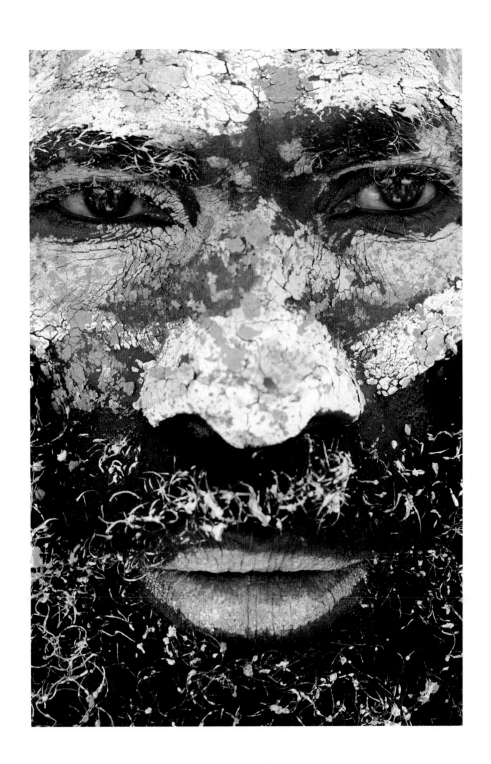

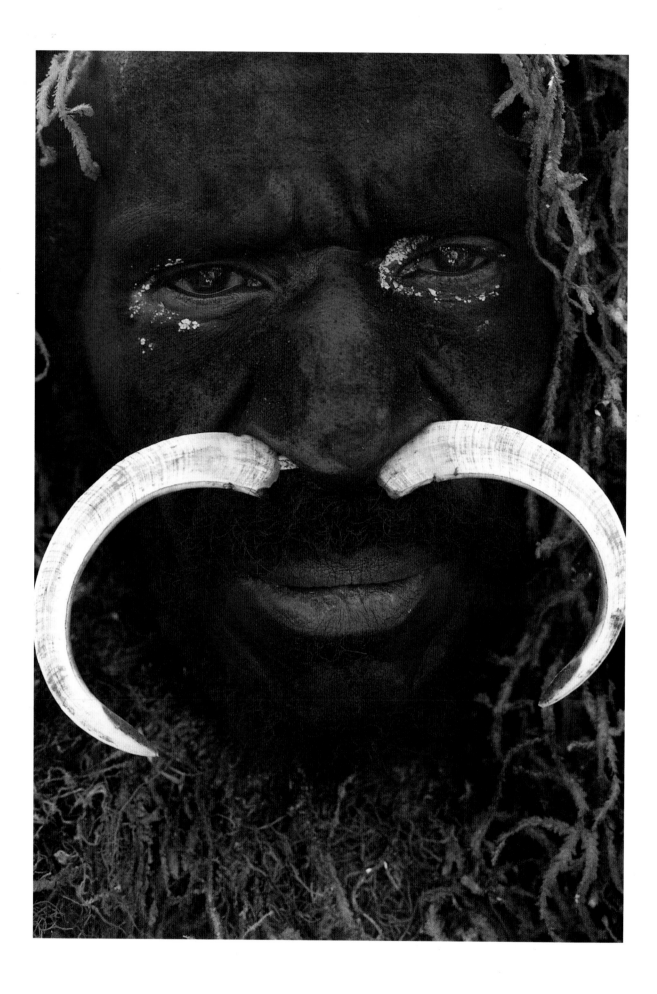

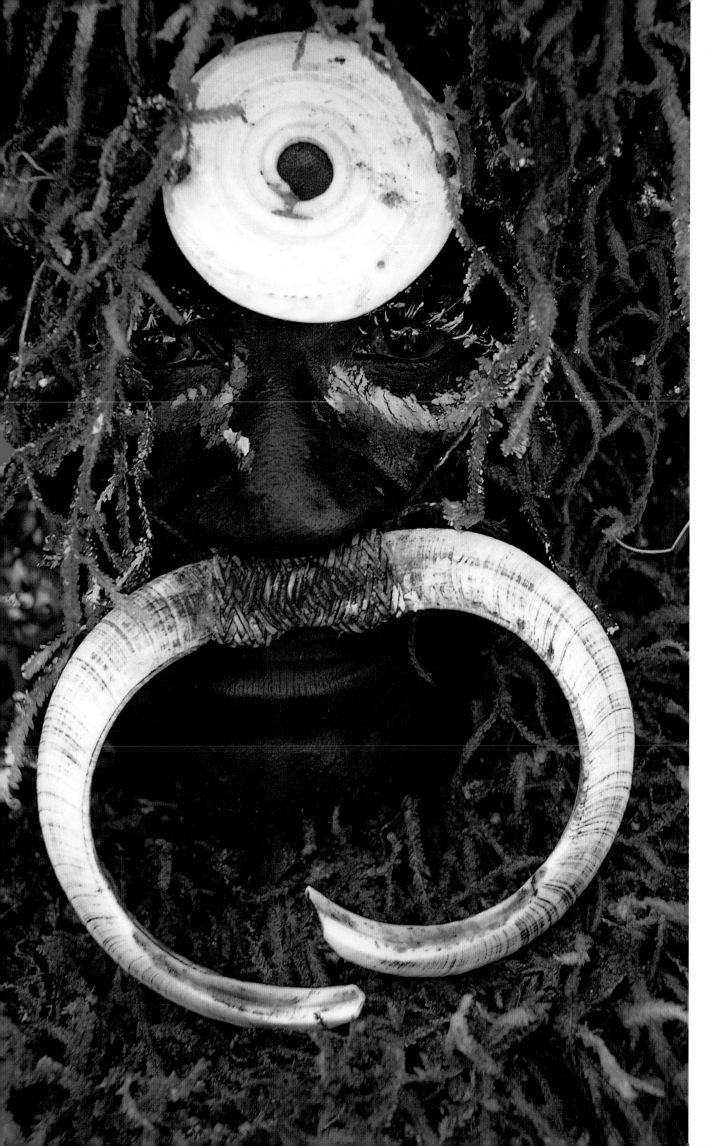

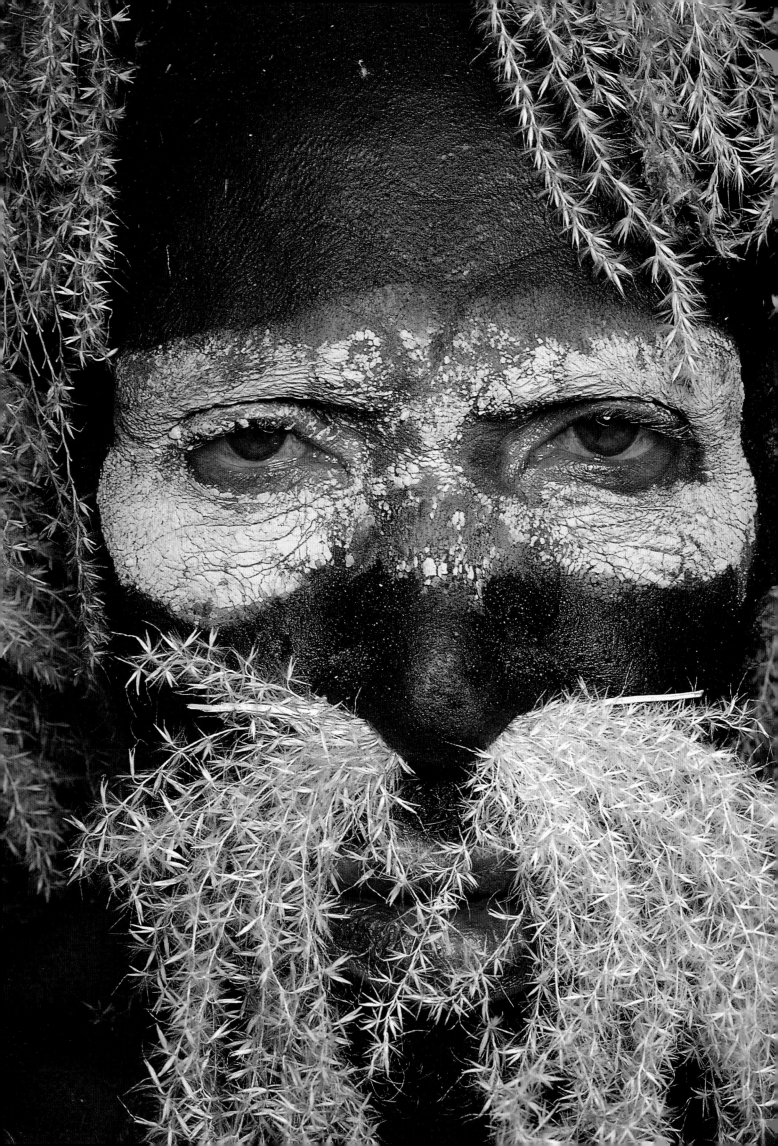

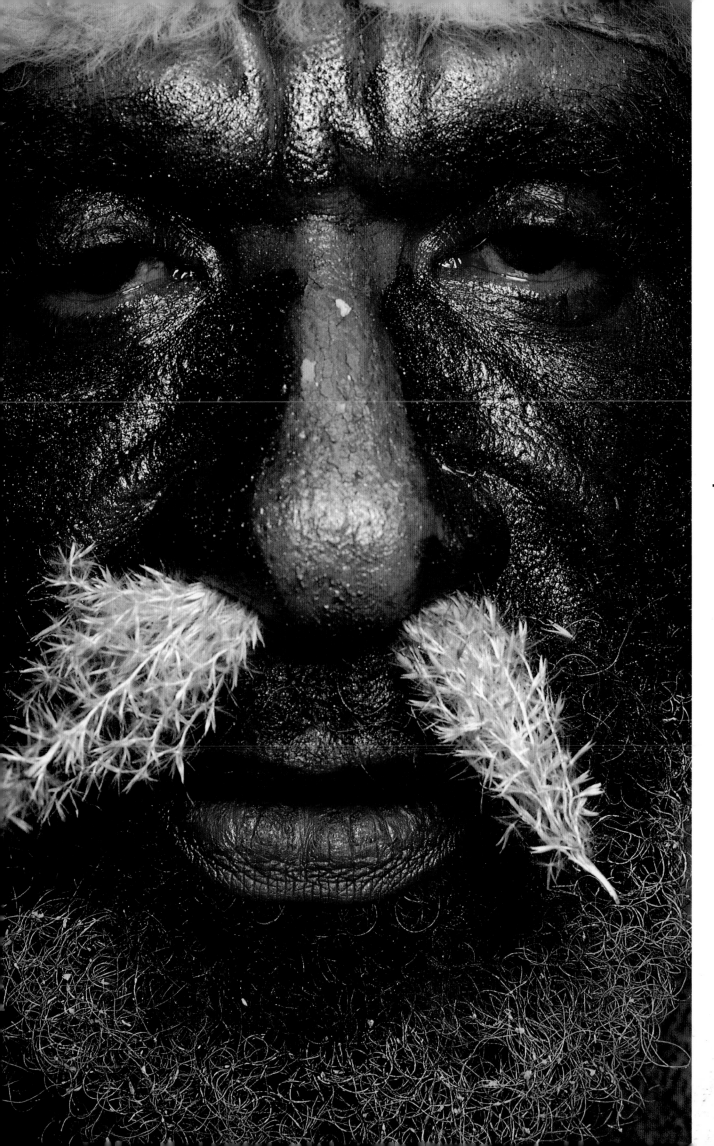

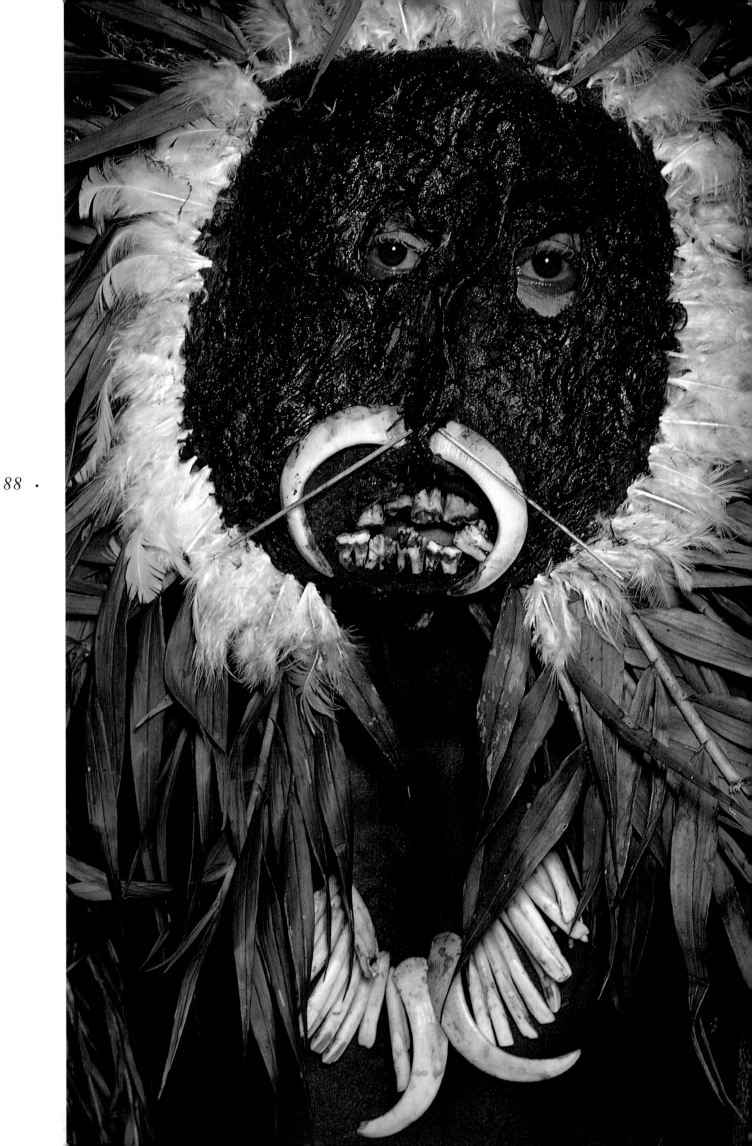

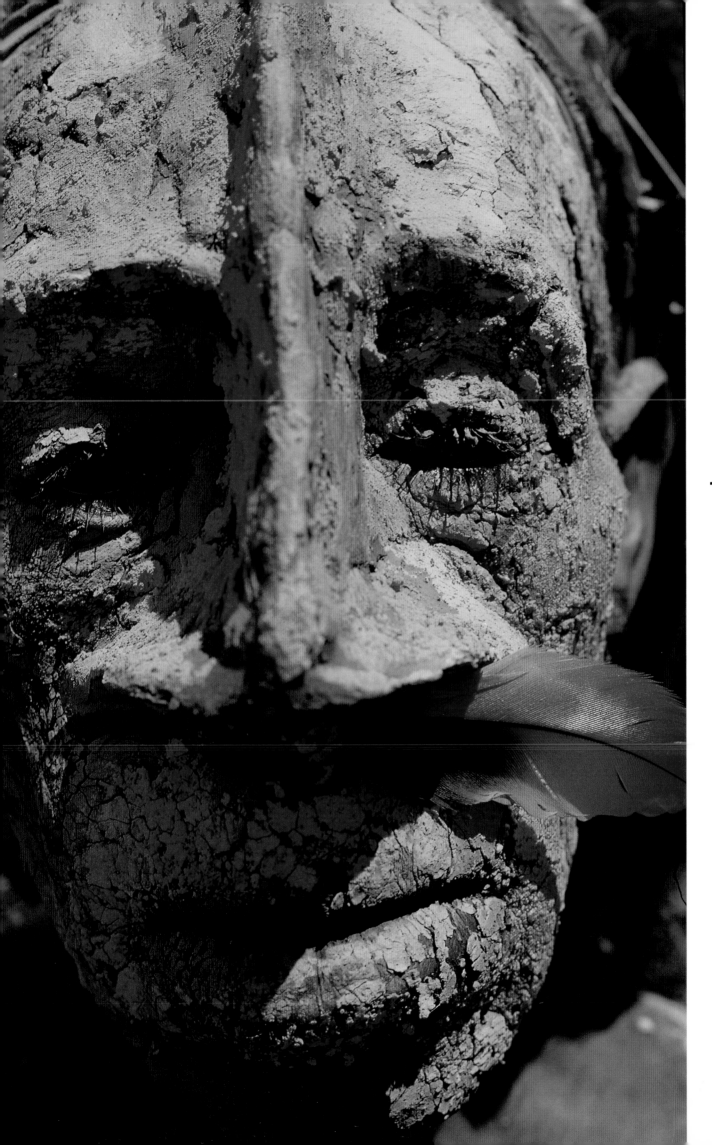

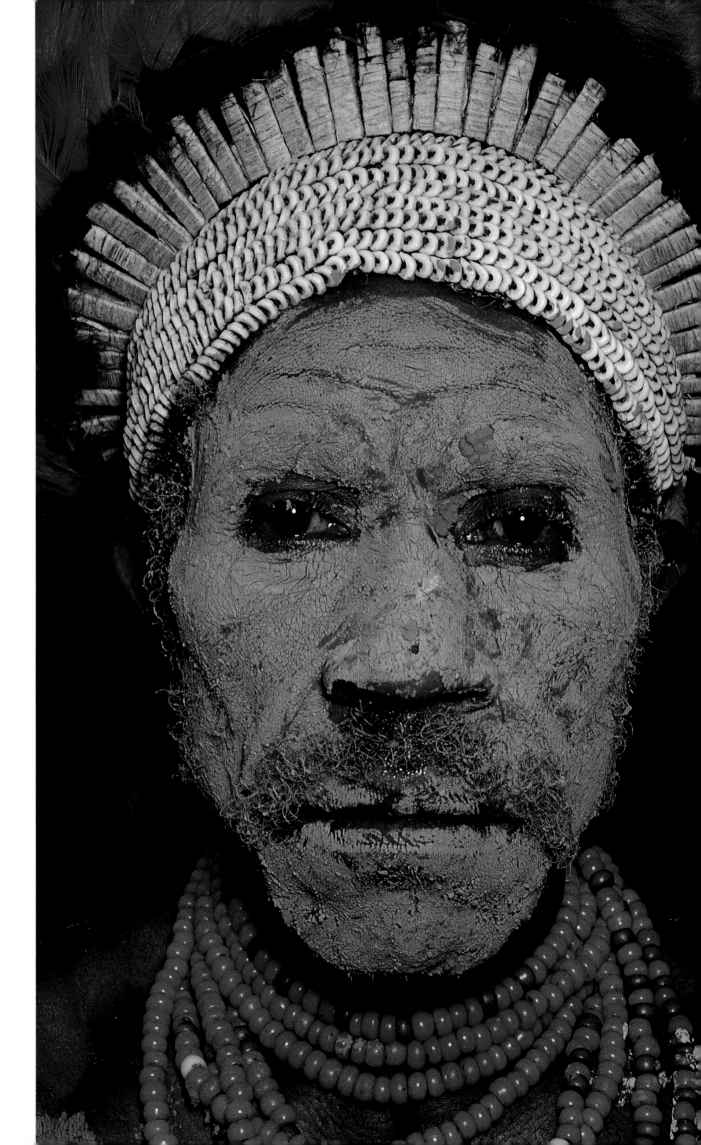

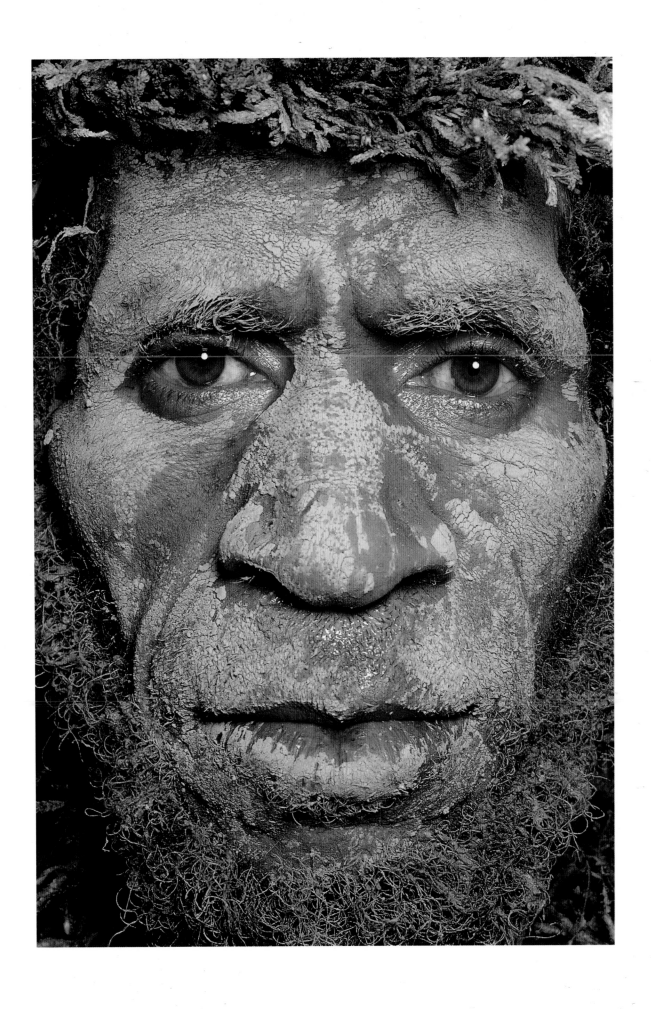

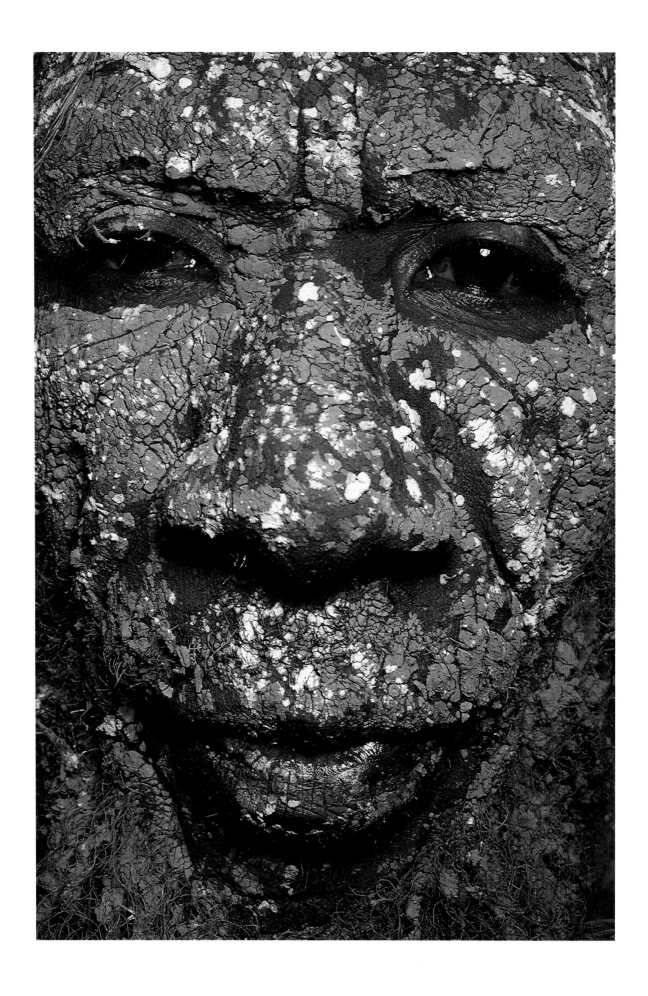

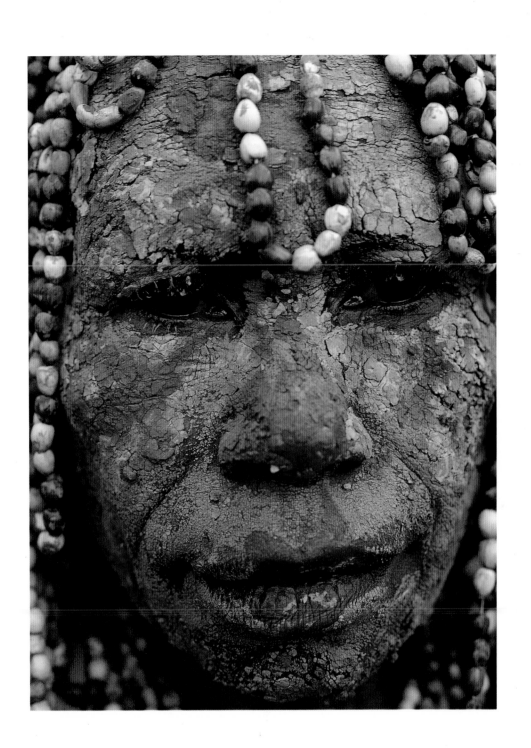

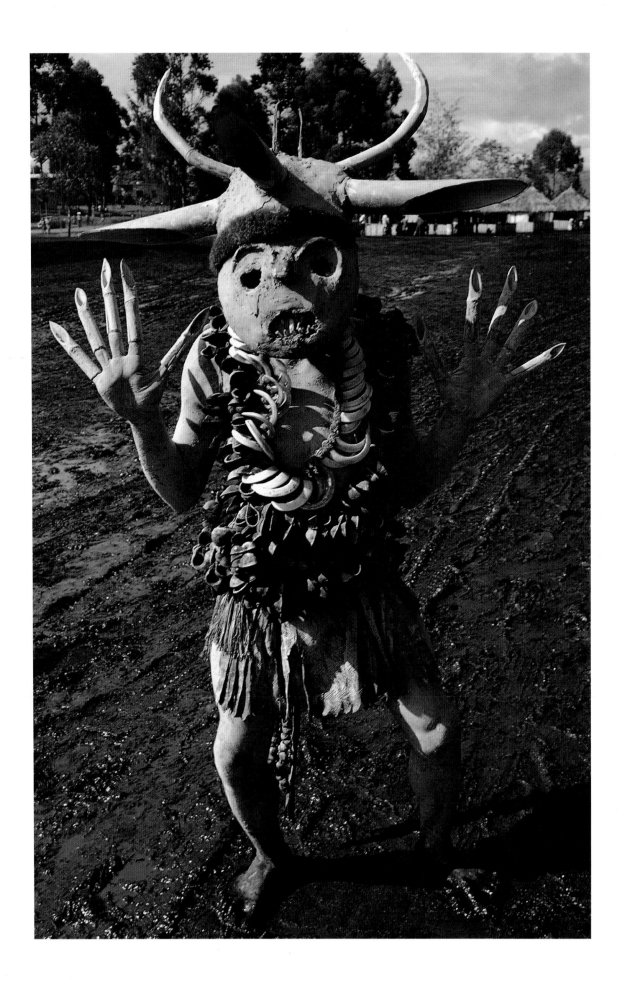

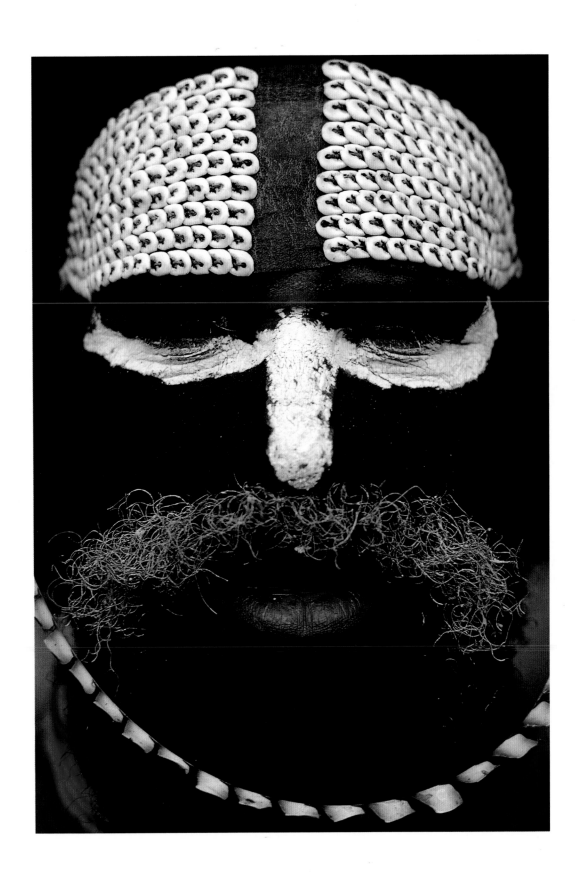

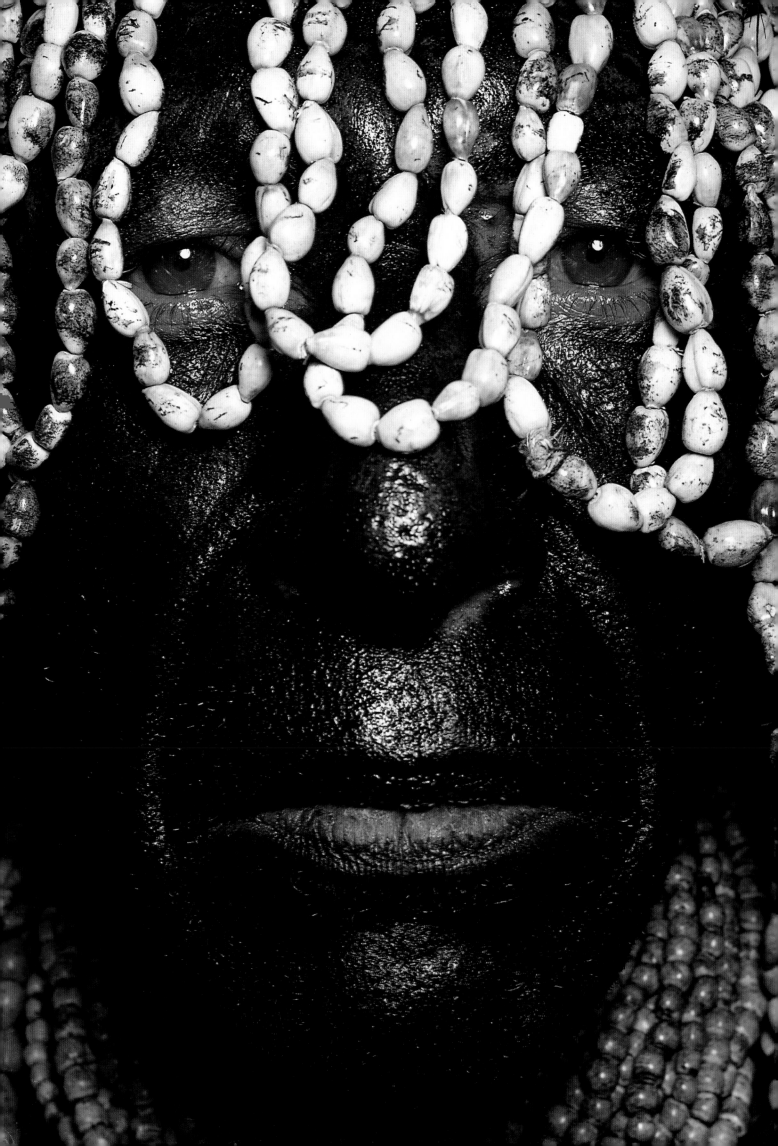

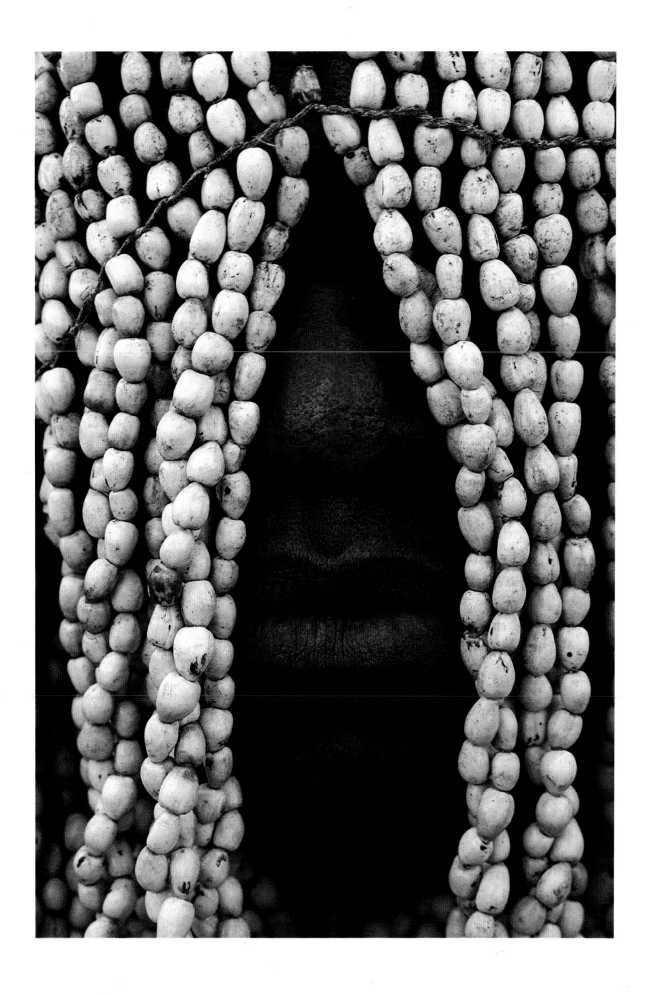

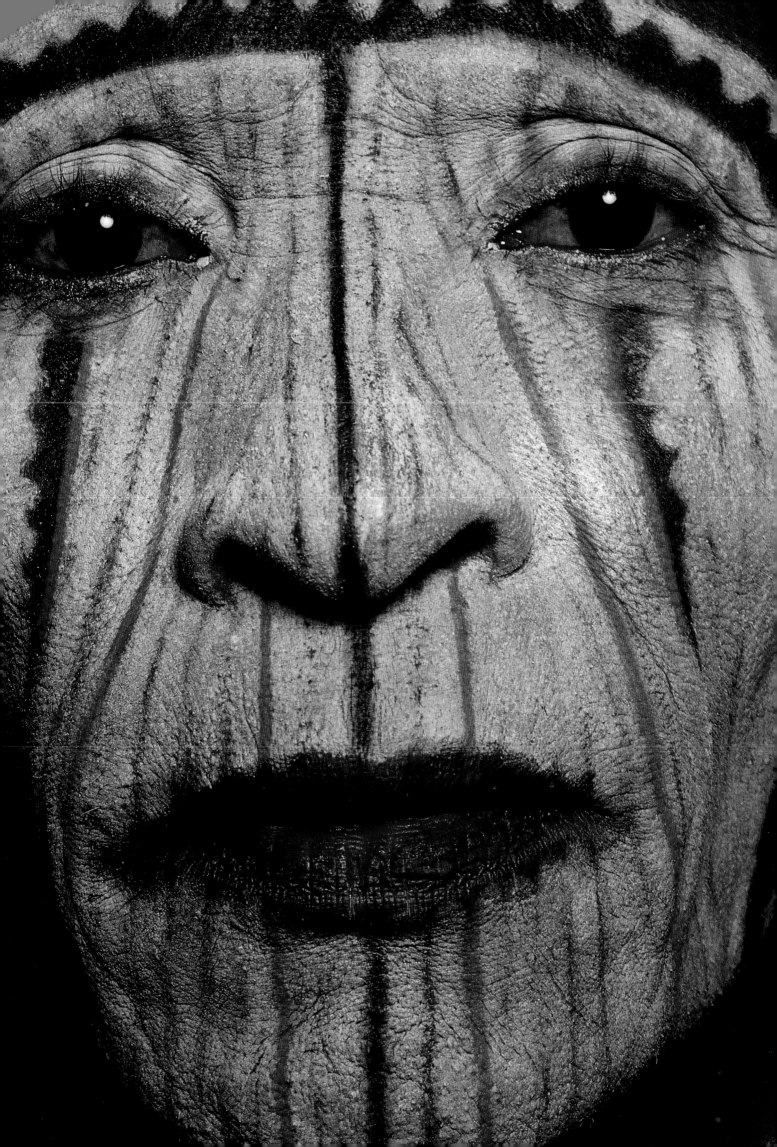

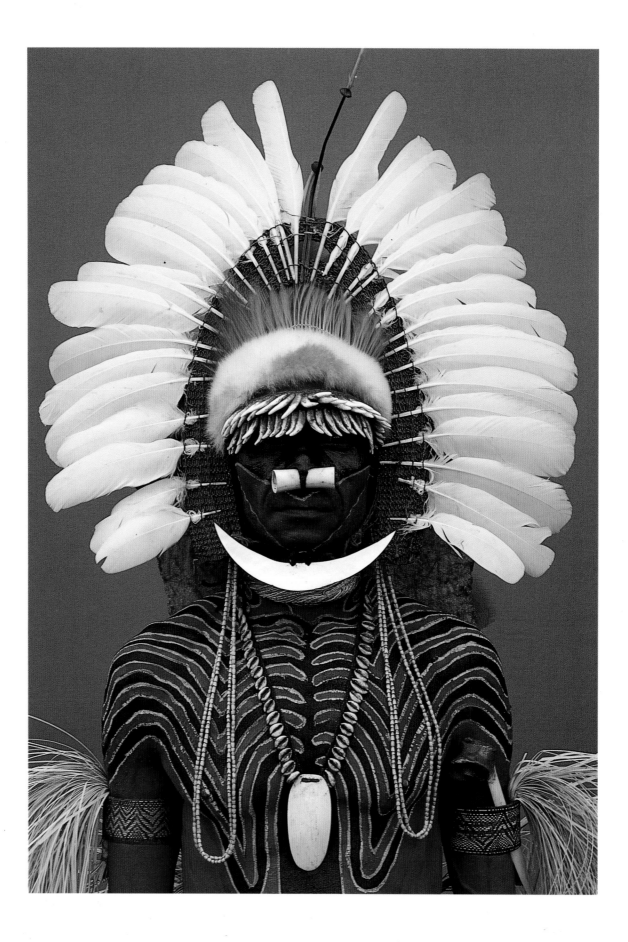

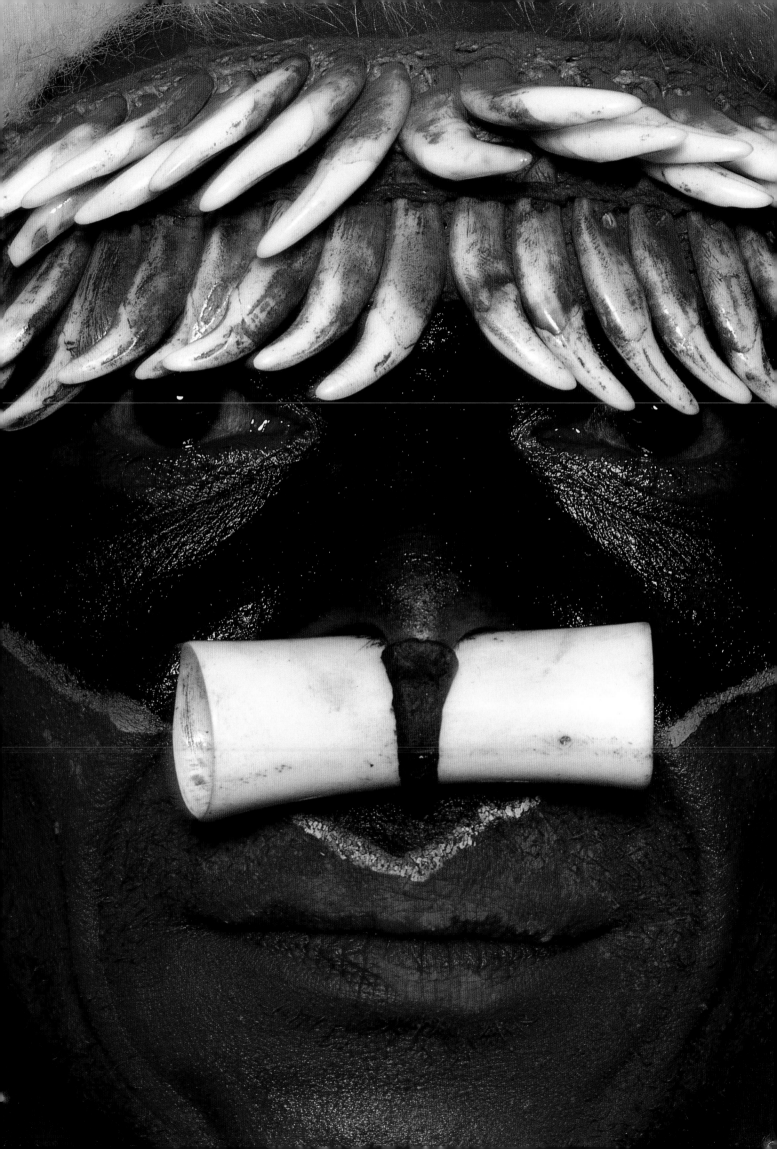

MASKS

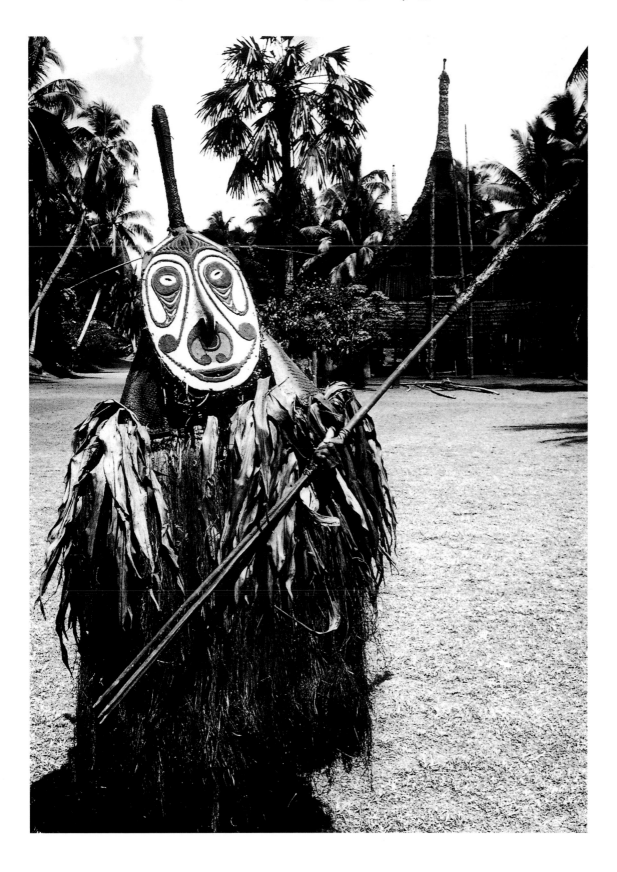

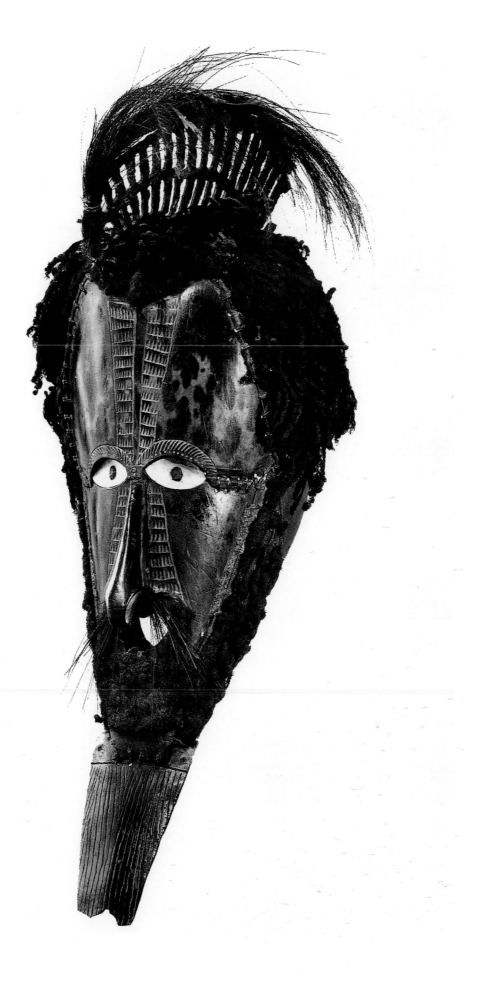

· 107

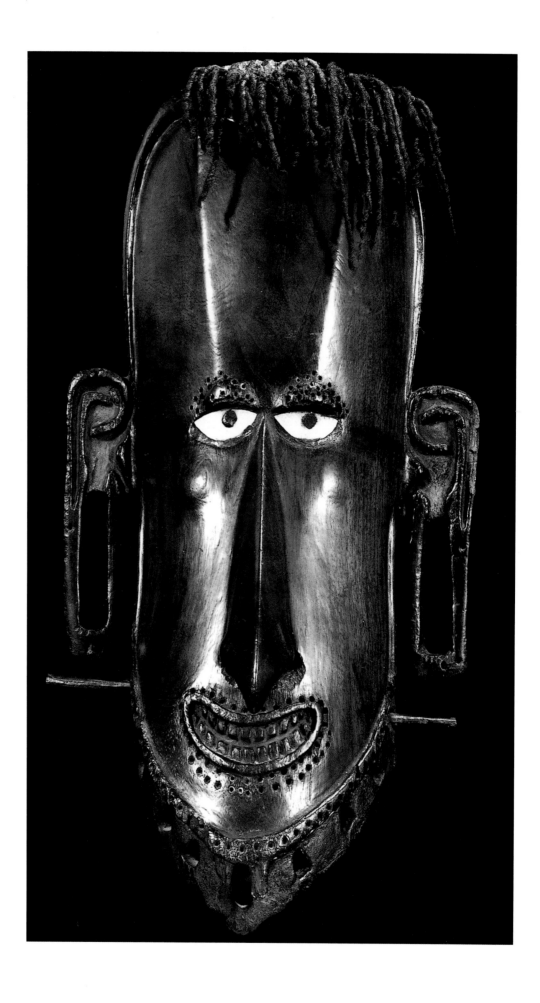

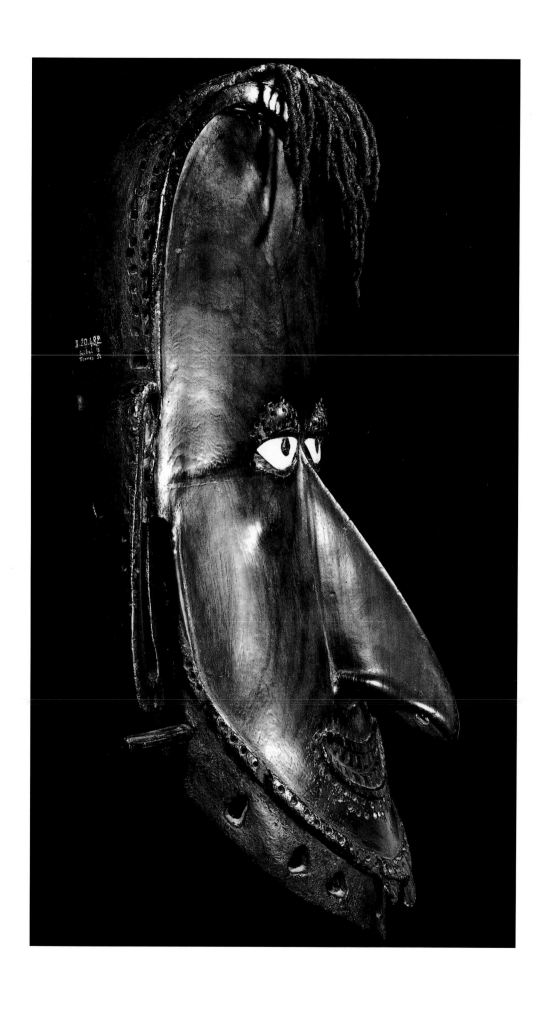

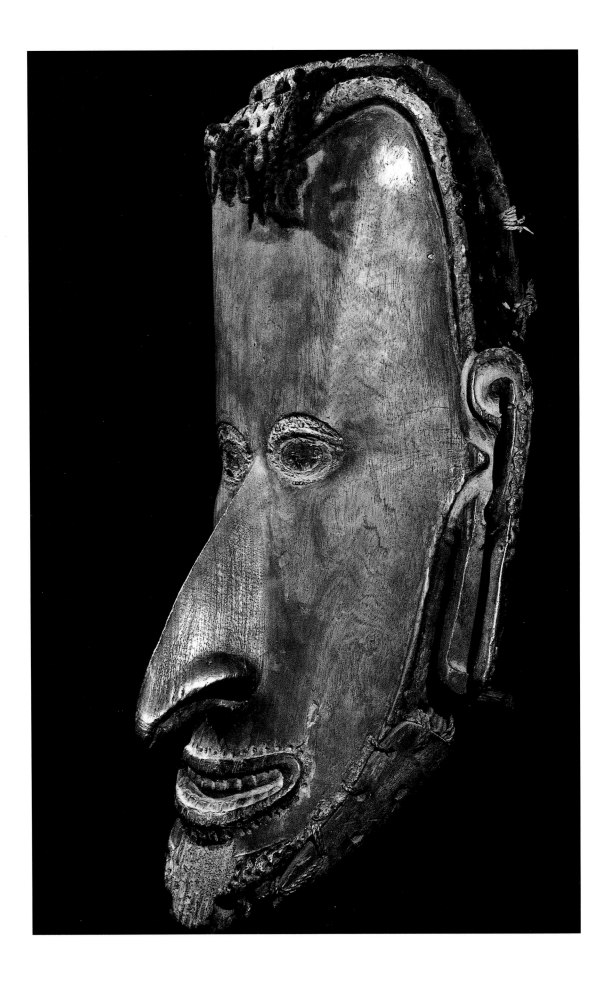

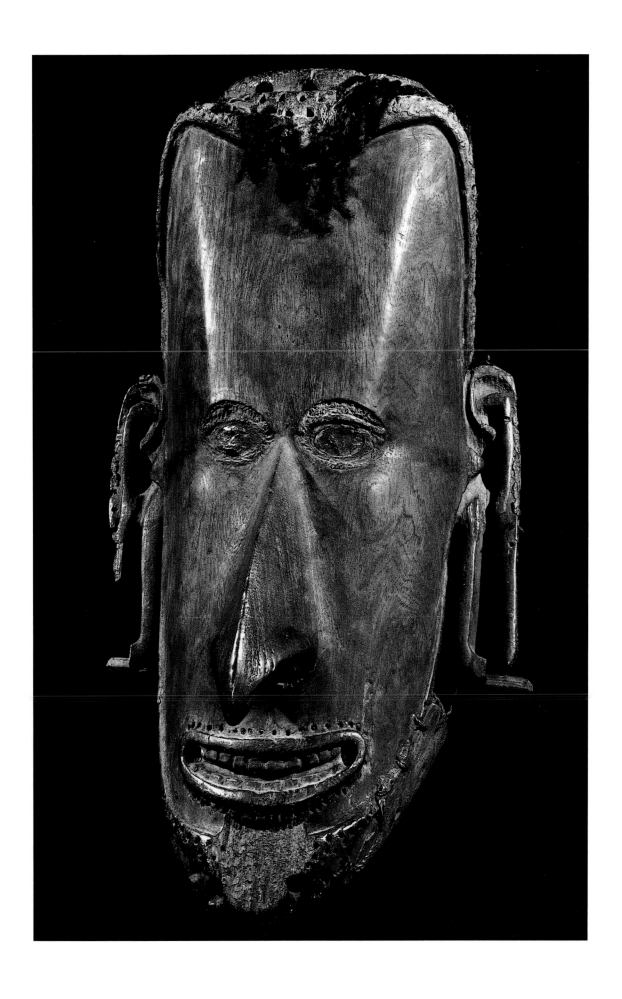

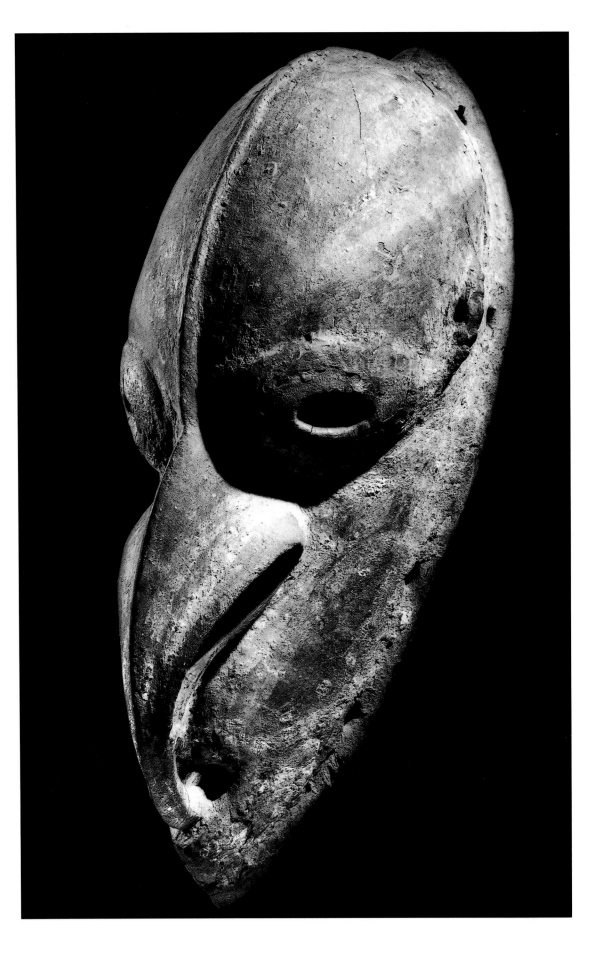

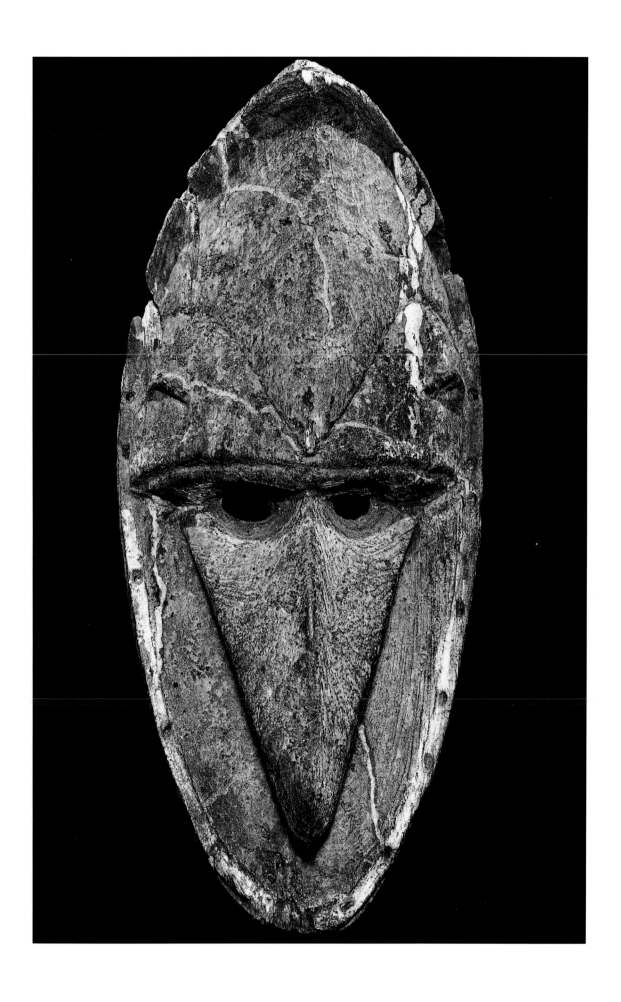

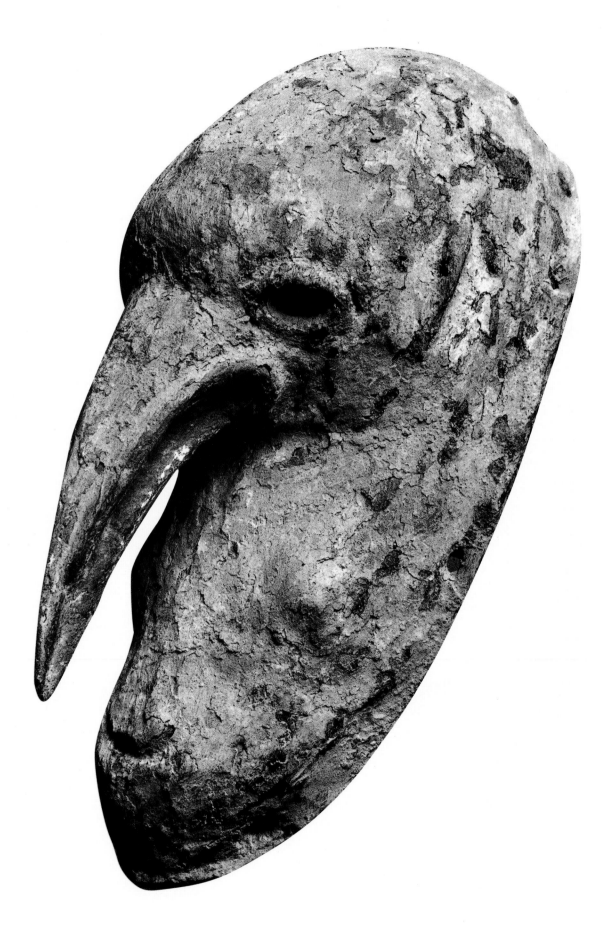

114 ·

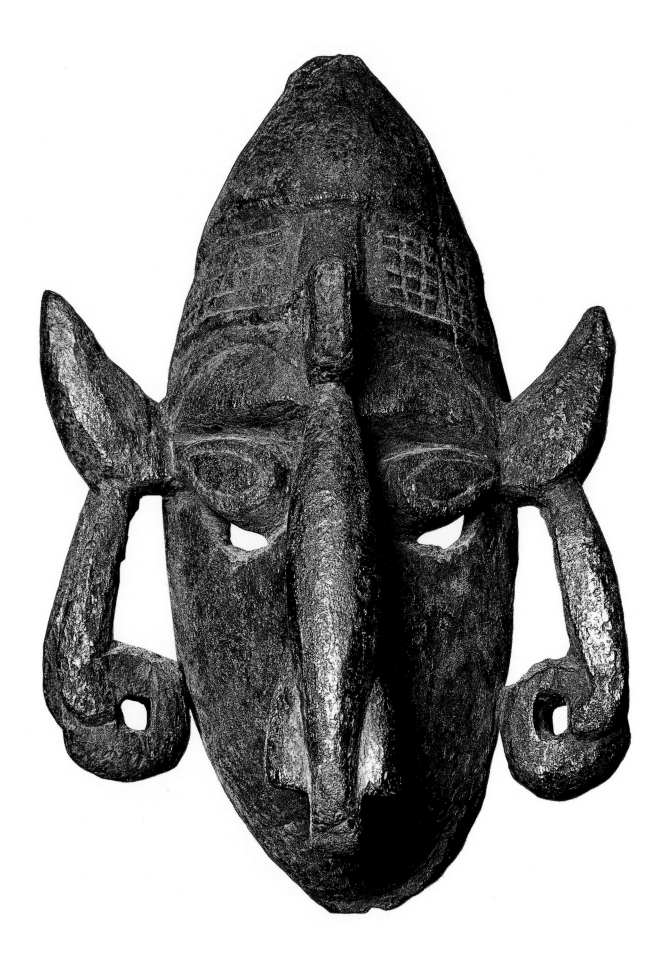

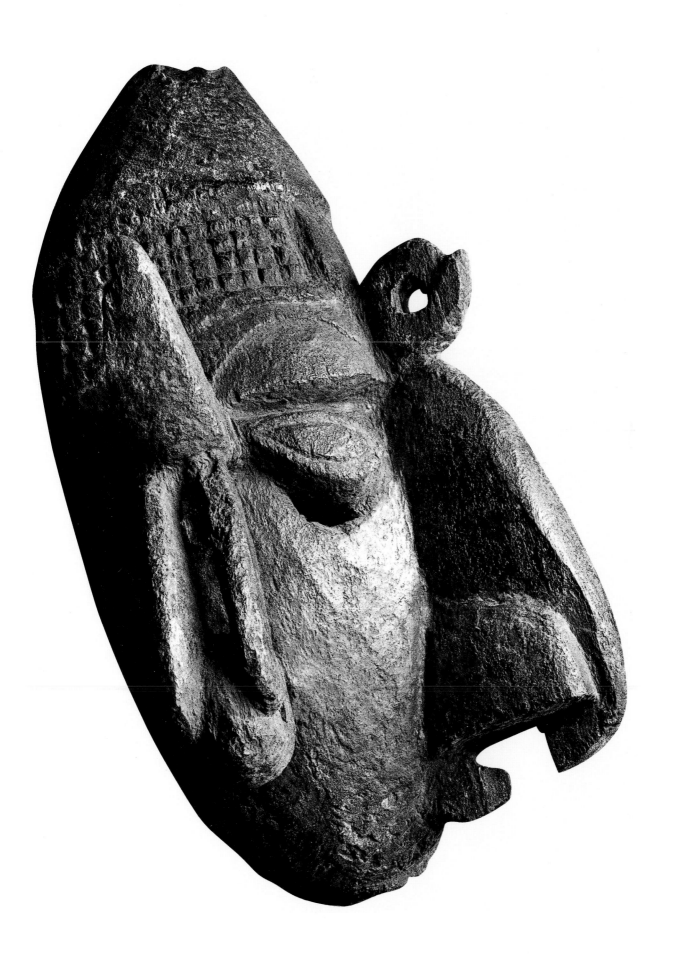

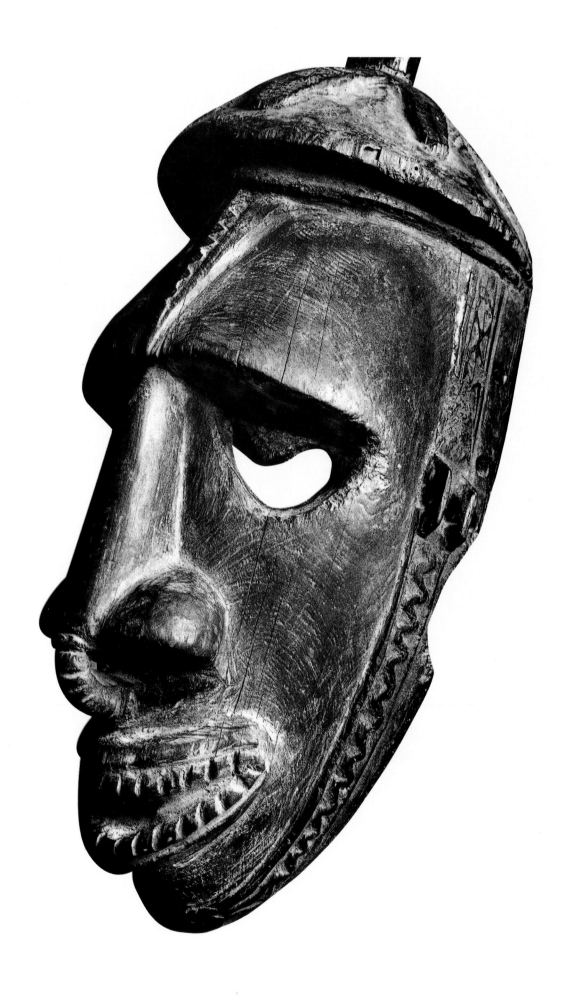

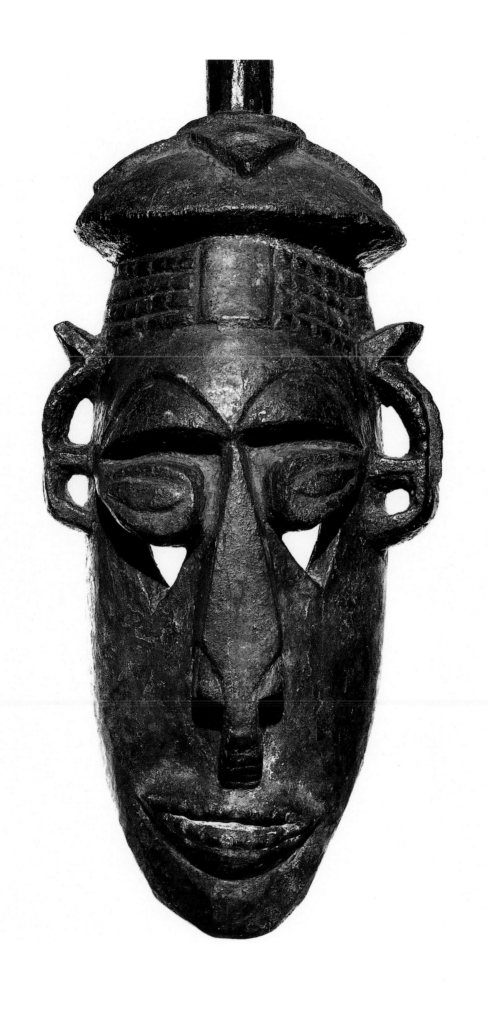

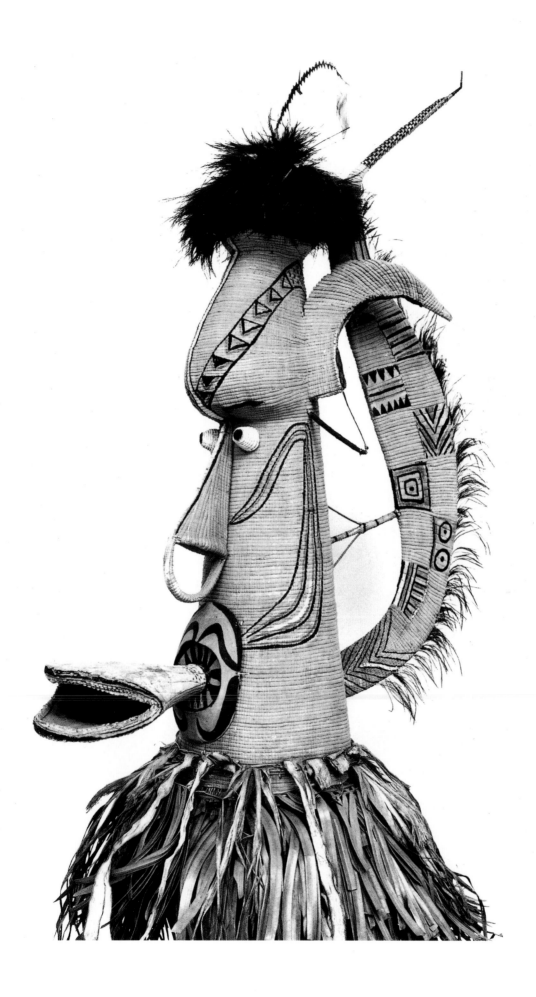

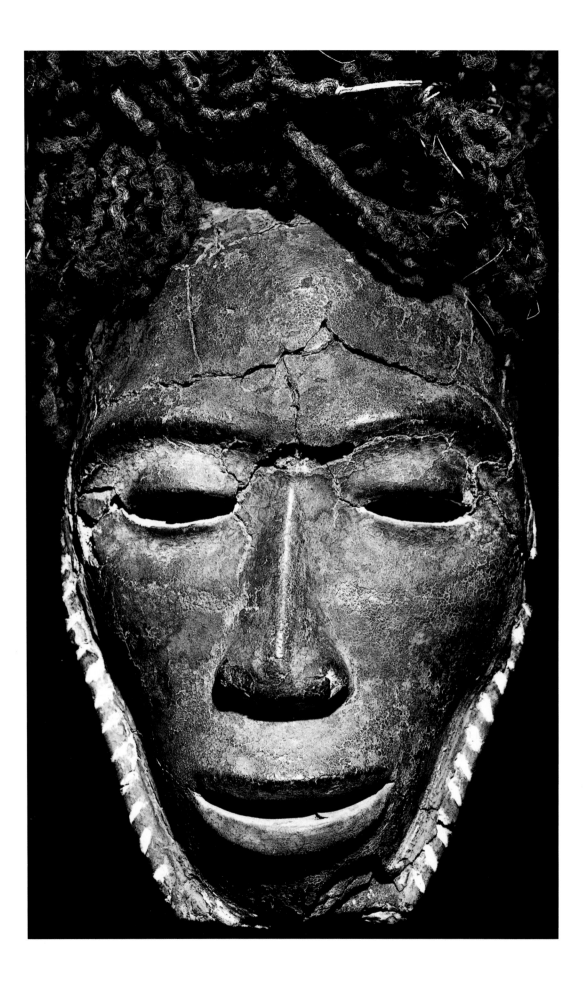

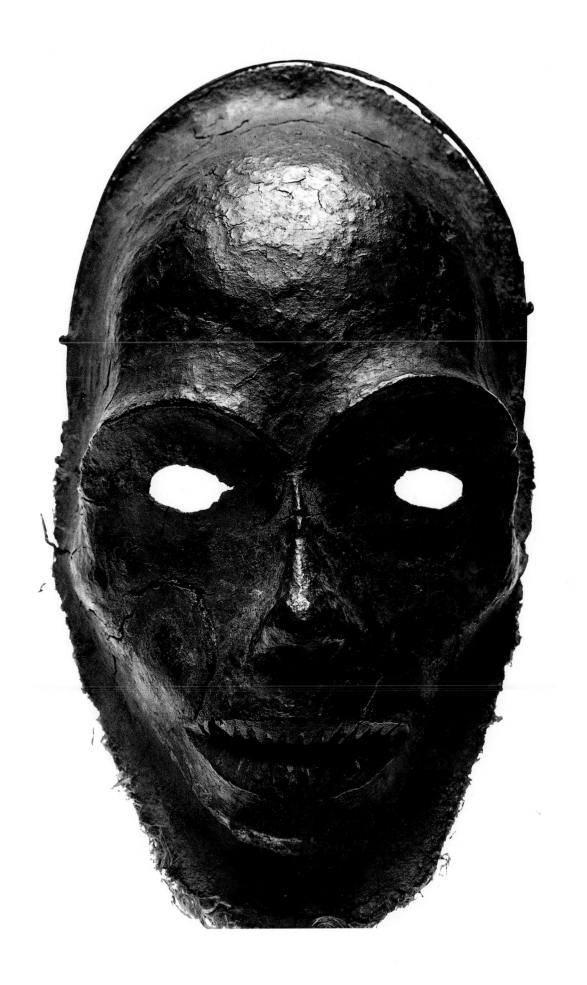

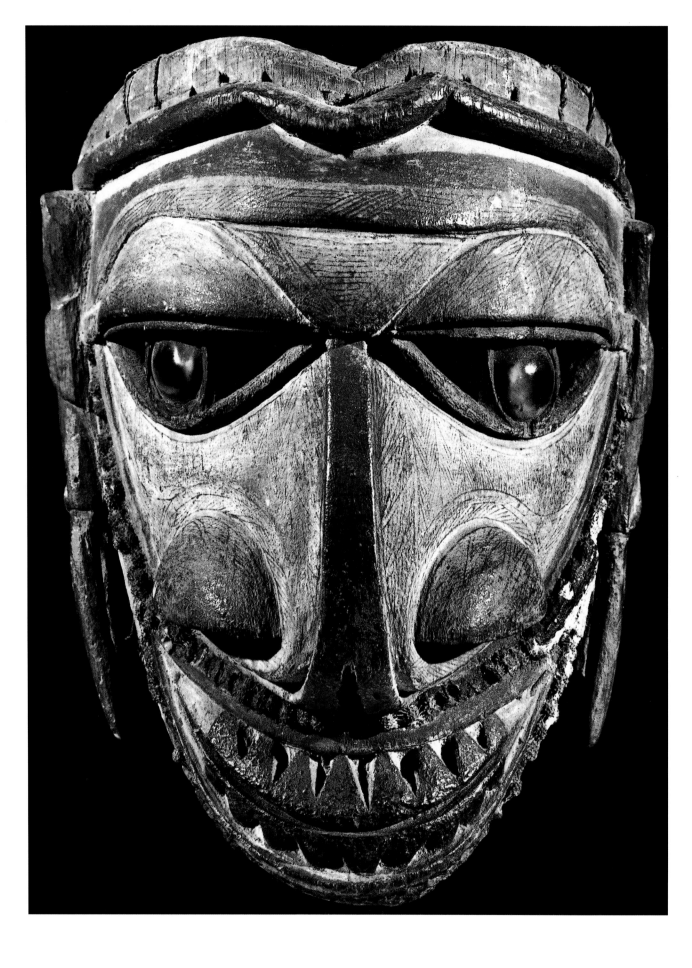

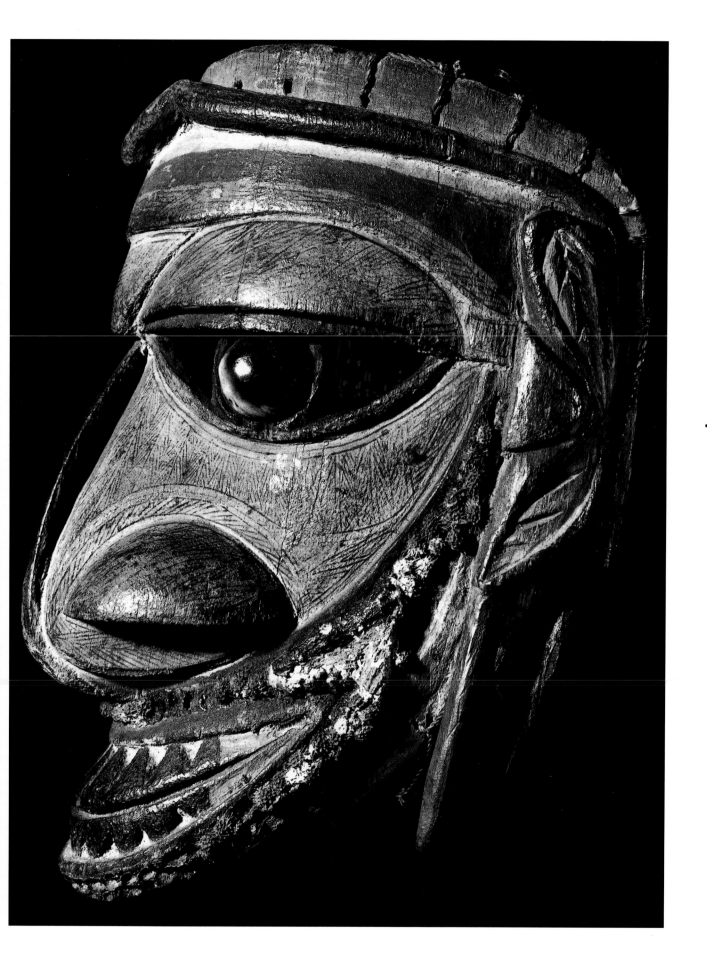

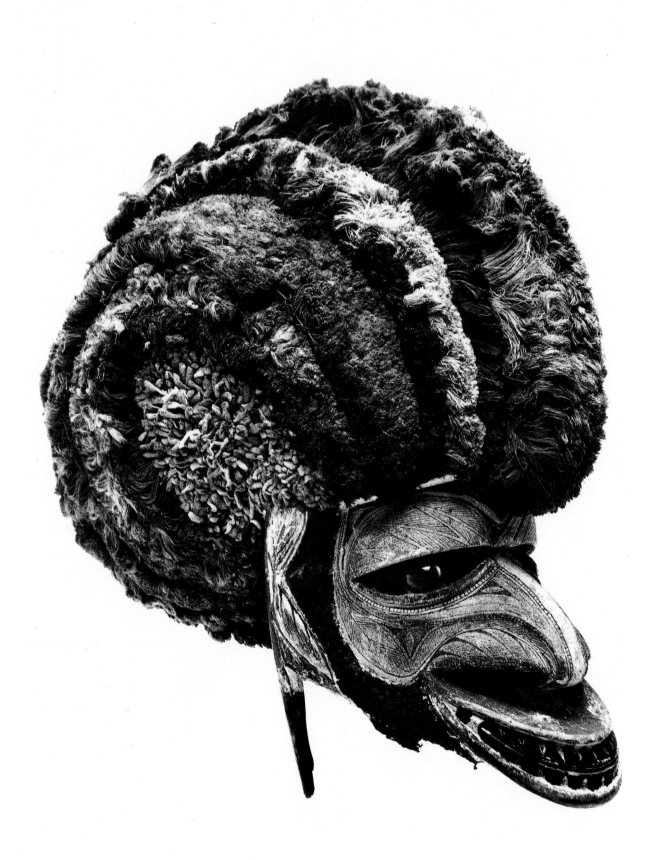

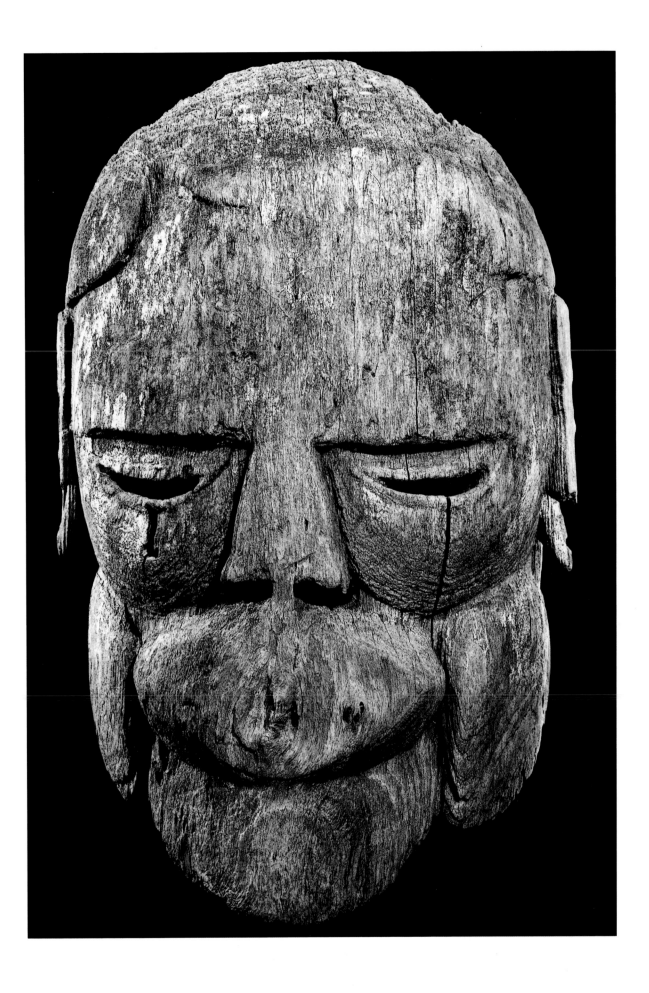

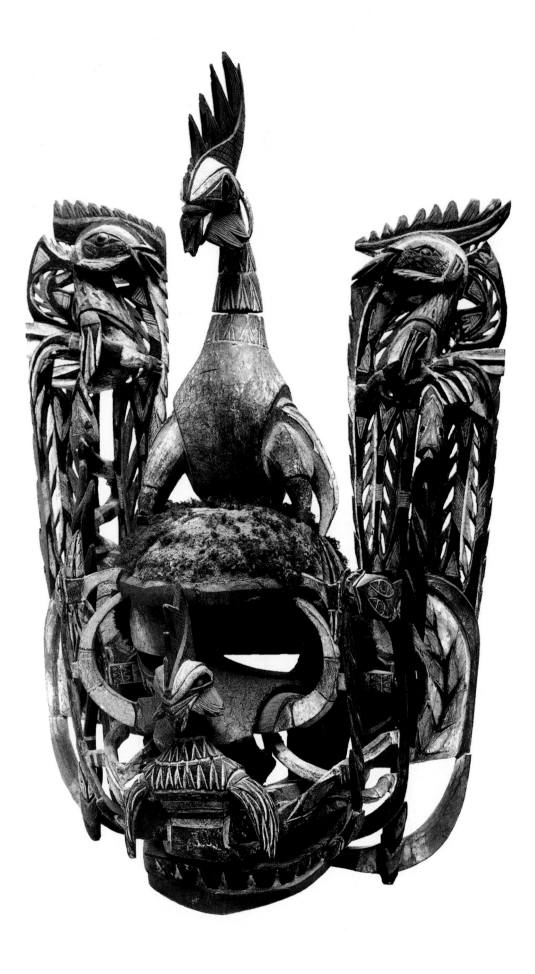

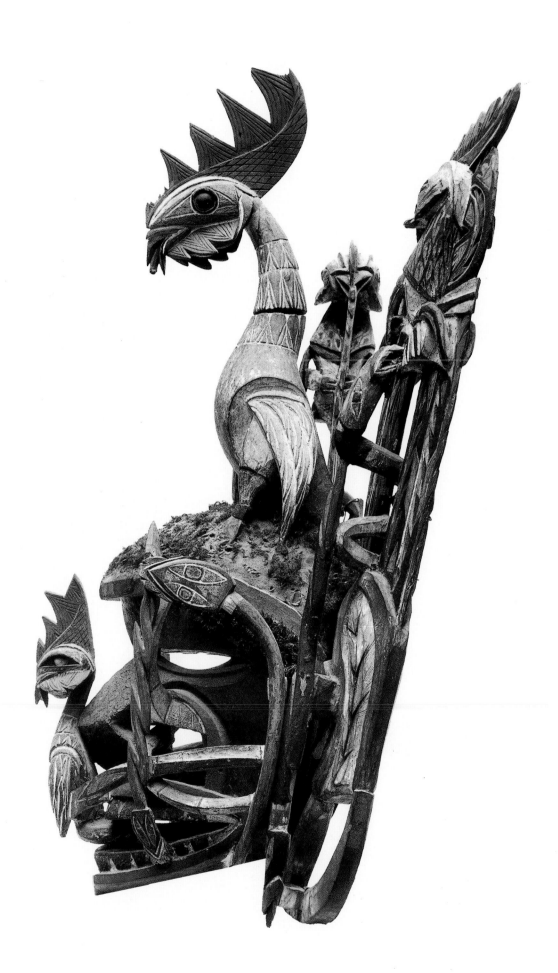

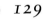
· 129

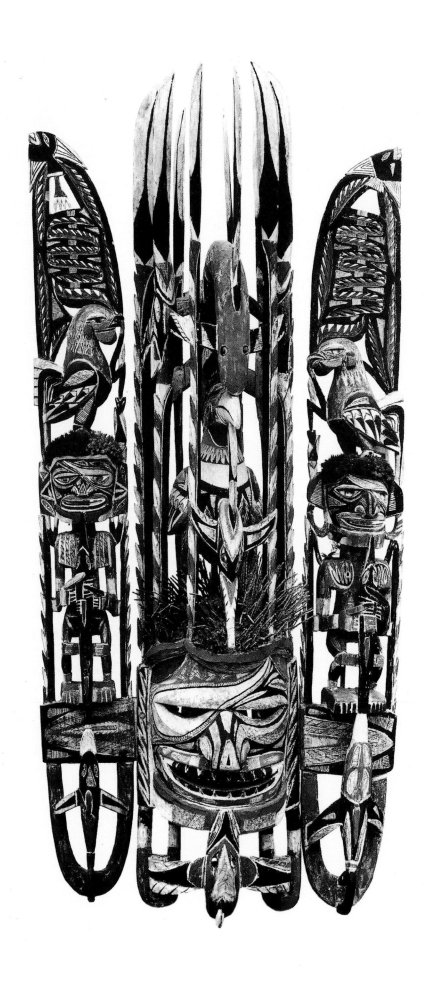

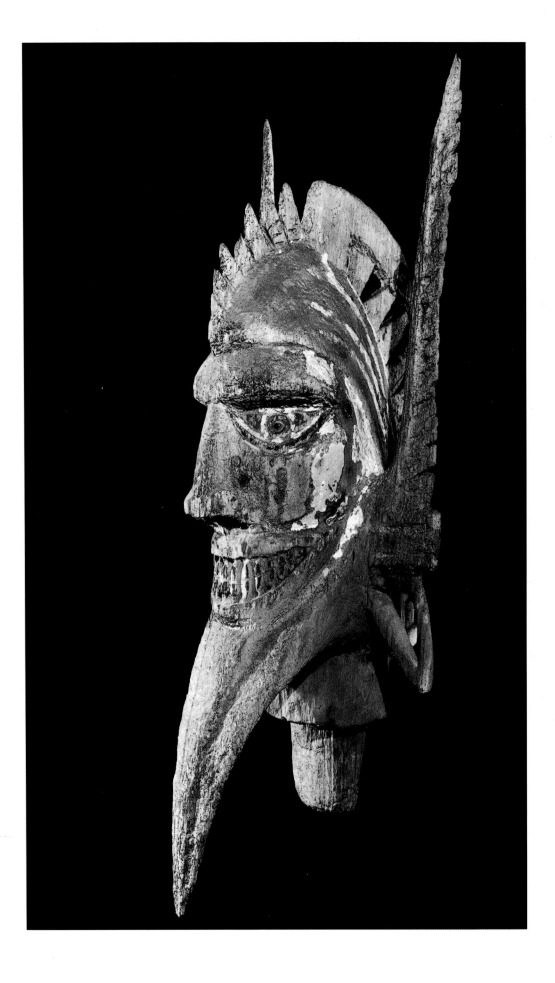

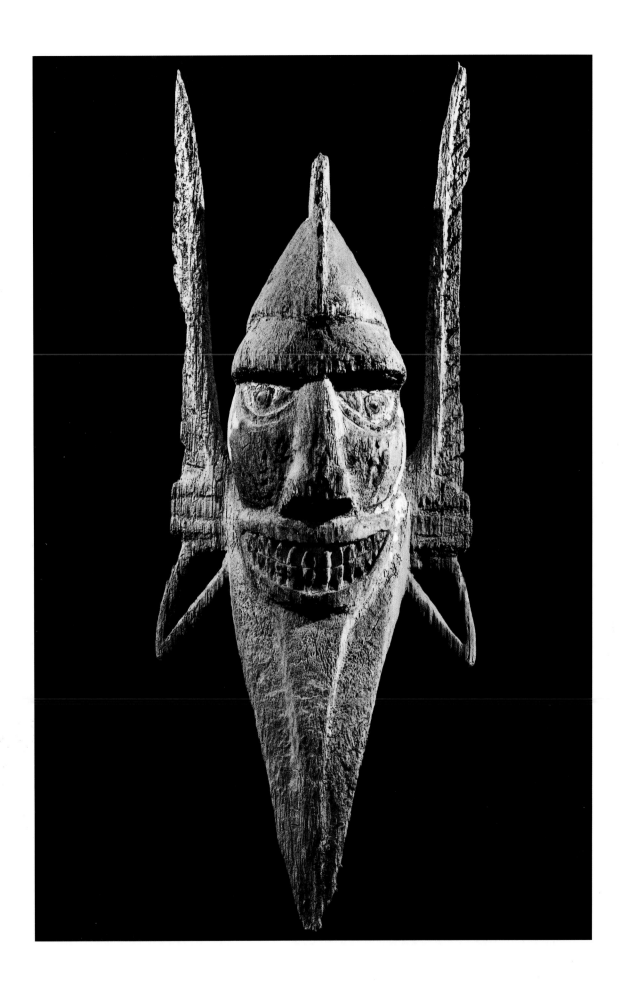

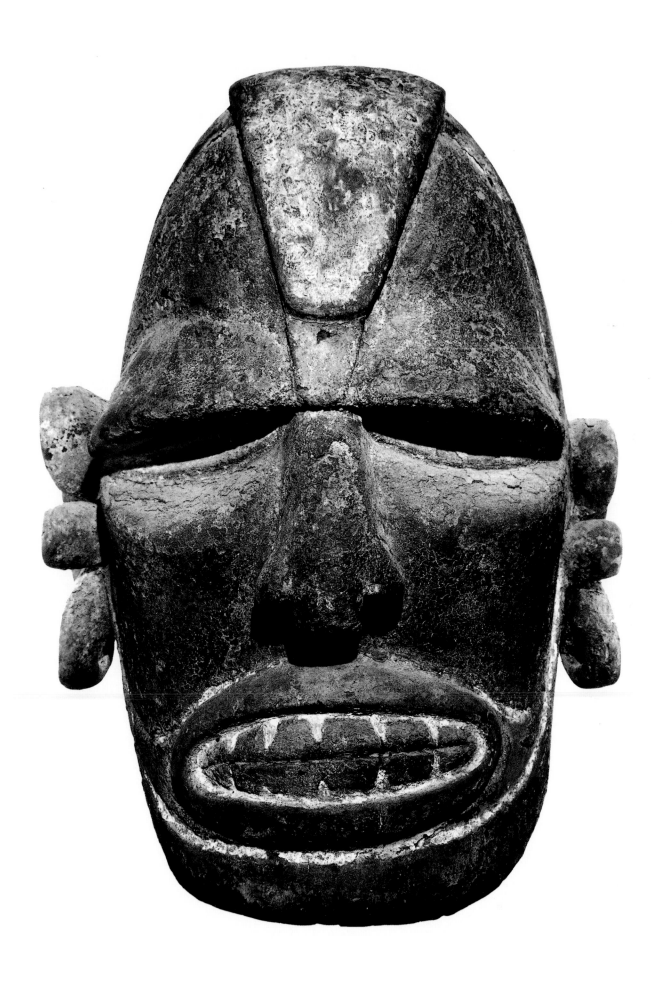

CAPTIONS : FACES

Page 41: A column of Mendi tribesmen parades at Sangre village during one of the stages of the *mok ink* ritual. They are preceded by an adolescent girl, or *mol shont*, one of several from the host clan, who welcomes the participants and dances just ahead of the ranks of men, carrying a digging stick.

Unfortunately, a photograph cannot adequately convey the spectacle of such an event. One's senses are overwhelmed by the military precision of the massed columns, the almost mesmerizing effect of a forest of plumes flexing in unison, the rhythmic stamp of feet so that the very earth shakes as they pass by, and the stirring chants of a thousand voices rolling majestically down the valley.

Richard Longley informs me that the structure and economy of Mendi society are based on a system of delayed gift exchanges, known as *twem*. Wealth and status are not inherited, and are instead acquired through a man's acumen and manipulation of the *twem* system. Through *twem* he establishes the friendships and alliances necessary for the well-being of both his clan and himself personally.

He is given his first pearl-shell valuable, or *kina*, when he is a boy, and he will lend this to someone prepared to set up a *twem* partnership with him. The debt will be repaid at a later date, with interest, in the form of one or two additional shells. This serves two purposes: it is an expression of goodwill and it places the boy in the repayer's debt.

In paying back the interest, a man may borrow *kina* shells from another *twem* partner or from his sister's husband, or he may demand his share from bridal or funeral payments made to his kin.

A man may also ask his *twem* partners for assistance with gardening, house building, food in times of famine, contributions toward the purchase of a wife, and protection during wartime.

Compared with these necessities, banked wealth is useless to a Mendi man. In essence, his wealth and prestige are determined by how much he has given away—leaving others in his debt—rather than how much he physically owns. Were he to follow our European values, which were founded upon the concept of individual aggrandizement, he would be ostracized by his own society.

The object of *twem* is to maintain the circulation of *kina* shells among an ever-widening circuit of *twem* partnerships. As a result, a clan builds up a network of alliances upon which it depends for its prosperity and security. To promote these, the Mendi stage elaborate public-wealth ceremonies to demonstrate their clan's assets and potential military strength.

Men who are particularly successful in *twem* exchanges become increasingly respected, both for their astuteness and for their ability to make allies. They become known as *ol homa*, or big-men. Although they have no official power, lesser men follow their decisions because their welfare depends upon the big-men. It is the *ol homa* who settle disputes, plan ceremonies, initiate pig kills, and wear the finest decorations during parades.

Lesser men, anxious to formalize ties to a big-man, offer him their daughters in marriage, and in agreeing to the union, a big-man thus gains further power and prestige. His brothers-in-law become his *twem* partners, and each new wife brings with her additional

gardening rights. Since it is the women who rear and feed the pigs, the more wives a big-man has, the more pigs he can raise.

Among the Mendi, pigs are not simply a source of food, but are important economically and socially. They are accumulated for sacrifices to ancestral ghosts, for bride payments and compensation following a death, and, above all, for *mok ink*, the spectacular pig kills and pork distributions held by groups of clans every twenty years or so to reinforce and demonstrate their wealth, strength, and associations with other clans. Such cyclical pig-killing ceremonies occur in several Highland societies (see, for example, the caption for pages 74, 75).

Pages 42–55: Huli tribesmen and a girl (page 51) from the Southern Highlands Province.

The men wear wigs of human hair, often impregnated with powdered ocher pigment and fringed with dried everlasting daisies (pages 42–48, 52). These everyday wigs curve downward over the head, but occasionally one still sees the upturned crescent-shaped ocher wigs that were once worn by bachelors participating in the now defunct *haroli* cult. A distinctive face-paint design (page 54) is also modeled after that worn by members of the *haroli*.

The iridescent blue fan-shaped plumage worn on the wig just above the forehead comes from the breast shield of the Superb Bird of Paradise. (Laurence Goldman, an anthropologist who worked among the Huli from 1977 to 1978, believes that traditionally this fan-shaped shield was positioned flaring upward when worn on the downturned everyday wig and was reversed on the *haroli* wig.) The Huli call this blue plumage *yagama*, from *yaga*, meaning "to fly." The black oval-shaped plumage worn immediately behind the *yagama* also comes from the Superb Bird of Paradise, in this case its cape (pages 42, 43), or from the Lawes Six-Wired Bird of Paradise (pages 44, 48), which the Huli call *kandi*. The red-and-yellow feathers radiating out from this blue/black combination come from the tail of a lorikeet. The sprays of orange plumage atop the wigs (pages 44, 46) are the flank feathers of the Raggiana Bird of Paradise; the black sprays (pages 45, 47, 48, 51) are cassowary feathers. The speckled blue, yellow, and black forehead bands, or *heda*, are the skins from a type of ground snake the Huli call *lepage*.

Artificial paints are preferred nowadays (pages 44, 45, 55) because their colors are more brilliant than the natural-earth pigments traditionally obtainable (pages 46–54). Sometimes one finds a combination of both (pages 42, 43).

Black pigment is simply powdered charcoal, which is mixed with water or tree oil before being applied. White-, yellow- and rust-colored clays occur naturally, although certain ocher clays are baked in leaf packages to increase the intensity of their color.

The Huli on page 48 wears a cowrie-shell necklace. Prior to European contact in the 1930s, cowries were used as a form of currency, as were *kina*, the crescent-shaped necklaces cut from gold-lip mother-of-pearl shells that were traded up from the coast (pages 42–47, 51–53). The black necklaces frequently worn with the *kina* are called *yari mabu*, and consist of cassowary quills joined together.

The young girl on page 51 wears a cap made from the fur of a possum, a marsupial that is also hunted for its meat. Unmarried Huli girls modestly cover their breasts with a sort of net bra, which they remove after marriage. This girl's body gleams with oil from the tigaso tree, which has been traded up from lowlands to the south. Her skirt is made from reeds, or *hurua*, that are cultivated in ponds and ditches, then flattened and dried. The hem has been darkened with clay to make it more attractive.

The decoration worn by the man on pages 52 and 53 is called *komia*, which is also the Huli word for the Lesser Bird of Paradise; the wig is topped with a Lesser plume. Invisible in these pictures is a striking arched tail made of leaves folded over a cane hoop, which is fastened to the belt at the rear. The dance for which this decoration is worn bears a marked resemblance to the male bird's courtship display, with the two participants hopping up and down beating their drums, then making brief dashes off to one side.

Huli men may wear as many as three front aprons, all of which are clearly visible on page 43. The short, women outer one, *nogo ere dambale*, is impregnated with ocher clay and fringed with pigs' tails. Beneath it is a knotted *pupai*, and below this is a knee-length women apron called a *dambale*. Fresh leaves, usually cordylines, are inserted under the belt as a rear-covering. Personal possessions are kept in a net bag, or *nu*, slung over the shoulders.

Pages 56–61: Tribesmen from the Mendi area, Southern Highlands Province.

Their elaborate feather headdresses are inserted into net-covered wigs (pages 56, 58). The blue columns rising obliquely on either side are fashioned from the flank plumes and tail streamers of the Blue Bird of Paradise; the two blue panels are made of feathers from the same bird or possibly from those of the kingfisher, and the red center panel is made up of parrot feathers. The tall serrated feathers dividing the colored panels are the occipital plumes from the King of Saxony Bird of Paradise. The orange sprays above are from the flanks of the Raggiana Bird of Paradise. Radiating out from the white forehead ornament—traditionally made from bailer shell, but in this case made from enameled metal—are gray green Lauraceae leaves.

Among the Mendi, headdresses often do not belong to the individuals wearing them. Instead, they are rented for a particular ceremony from men who

specialize in the trapping of birds and the manufacture of sets of feather headdresses. In addition, other ornaments such as *kina*-shell necklaces may also be borrowed or rented for the occasion. The necklaces are set off against a bed of green moss, and the most valued ones have a natural golden sheen, which is enhanced by polishing and rubbing ocher clay over the surface. Woven-string aprons are worn in front, with a rear-covering of leaves, which are tucked into the men's cane belts, in back. To make their bodies glisten attractively in the light, they have rubbed on tigaso-tree oil, which is traded up from Lake Kutubu in bamboo tubes. Their faces are blackened with powdered charcoal, and their noses and mouths are picked out with bright artificial paints. White clay highlights their eyes and beards.

Page 62: A prepubescent girl from the Mendi area, Southern Highlands Province.

She is decorated as *timp tenalte*, a bride for the spirits, and she sits before the men's cult house during the final day of the *timp* ritual. Being so young, she poses no threat to the men, who consider menstruating women to have a dangerous polluting influence.

She wears a blackened bride's net bag over her head, and her body is also blackened and oiled. Her face is divided into two colored halves. According to information provided by David Eastburn, the side painted black represents the spiritual future awaiting her clan, and the red half its economic fortunes. It is interpreted as an ominous sign if either side becomes smudged during the ceremony, perhaps by sweat causing the paints to run into each other. Andrew Strathern adds that black/red contrast is reminiscent of color combinations used in the Mount Hagen area, where black connotes male, representing ancestors, and red connotes female, representing exchange, the connections that cause wealth to flow.

Page 63: A widow in mourning, from the Mendi area, Southern Highlands Province.

Called *ten weya*, she is covered with clay and wears an ankle-length skirt, or *hurin*, made of sedge, a type of river grass. Around her neck hang numerous loops of pale gray grass seeds (*Coix lachryma*) called holo, which together may weigh as much as thirty pounds. Following custom, she may discard one strand each day during the initial period of mourning. Depending on a woman's closeness and relationship to the dead person, she may wear this costume anywhere from a few months to a couple of years.

Pages 64, 65: Two girls from the Mendi area, Southern Highlands Province.

These adolescent girls are decorated for the role of *mol shont*, and will dance with the men during an *ink pomba* ceremony, one of the stages in the *mok ink* ritual. (For a fuller description, see the caption for page 41.) The red, yellow, and blue paints are artificial pigments, purchased from a local trade store along with the beads for the girls' necklaces. White cockatoo feathers decorate the headpiece, and different-size pieces of bailer shell are worn on the forehead and chest.

Pages 66–69: Four Kauil tribesmen from the Tambul area, Western Highlands Province.

Their headdresses (pages 66, 68) are similar to those worn by the Mendi (pages 56, 58). The tall straight feathers rising on either side of the main panel (page 66) come from the sicklebill bird of paradise. Protruding forward on either side of the men's eyes are cassowary leg-bone spatulae, seen most clearly on page 68. Their *omak*, ladderlike strips of pit-pit cane worn on the chest, denote how many times the owner has participated in a ceremonial exchange of goods (pages 66, 68). A particularly long strand usually indicates that the wearer is a big-man: he has to be a wealthy and prominent individual to have given away so much. String armbands are a further indication of the importance of these men. Long net aprons that are topped with leaves are folded over their cane belts, and impressive ceremonial stone axes protrude from the rear. The men's dark appearance serves to exaggerate their size.

Pages 70–72: Two Melpa tribesmen from the Baiyer River area, Western Highlands Province.

The man on page 70 wears his second-best set of feathers, consisting of a single striped bird-of-prey feather flanked by the blue-gray feathers of the Goura Pigeon and surmounted by the russet plumes of Raggiana. His black horn-shaped wig has been copied from those worn by the adjacent Enga people, and it is bordered along the base by Lauraceae leaves and a cuscus-fur headband, above which is pinned a Superb Bird of Paradise breast shield. A slender pearl-shell crescent pierces his nasal septum. From his neck hang two *kina* shells and an *omak*. The man on page 72 wears the iridescent blue breast shield and oval black cape of the Superb Bird of Paradise, topped by red-and-black Pesquet's Parrot feathers, serrated pale blue occipital plumes from the King of Saxony, and the russet flank feathers from the Raggiana. Covering his forehead is a curved bailer shell.

Page 73: A Melpa man from the Mount Hagen area, Western Highlands Province.

This man was wearing coconut-shell breasts, and was decorated with the bright colors and designs usually worn only by Melpa women. He aroused considerable amusement in this transvestite role at the 1967 Mount Hagen Show. Andrew Strathern points out that transvestism does not, however, have any formal part in traditional Melpa ceremonies.

Pages 74, 75: A Komblo tribesman from the Wahgi Valley, Western Highlands Province.

These are front and rear views of a *peng* wig (*peng* also means "head" in the mid-Wahgi language). The wigs are made toward the end of the cyclical Pig Ceremony, a few months prior to the climactic killing of the pigs, and are worn by those men and unmarried girls whose fathers wore wigs at the previous Pig Ceremony.

This wig consists of a bamboo-and-vine framework, over which is stretched a bark-cloth base. A layer of adhesive burrs is added, to which human hair is attached. The surface is covered with a golden tree-gum, and the base and ocher-colored panel at the back are delineated with strands of braided yellow fibers. A double row of green scarab beetles runs down each side of the wig, framing the wearer's face.

Around his forehead is a circlet of red Pesquet's Parrot feathers. The tall, curved black plumes in the front come from the Princess Stephanie Bird of Paradise, whose iridescent bodies are fastened to the bases. To the rear (page 75) are one or two sicklebill bird of paradise plumes. Sweeping out horizontally are the creamy pale-yellow-and-white plumes of the Lesser Bird of Paradise.

(This information was supplied by Michael O'Hanlon, an anthropologist studying Wahgi self-decoration. The wig was worn by Kinden, a Komblo big-man. To give some idea of the commercial value of these plumes, O'Hanlon points out that the 1980 prices for a single new sicklebill or Princess Stephanie feather is around ninety and sixty dollars respectively!)

Pages 76–81: Five Chimbu men, from Chimbu Province.

The first (page 76) wears a circular forehead ornament made from the base of a conus shell. Two strands of white nassarius shells hang down on either side of his red-tipped nose. Red-and-black Pesquet's Parrot feathers and green feathers from a lorikeet jut out horizontally from these strands like whiskers. (To ward off insects at night, the men sleep in smoke-filled huts, which may to some extent account for their bloodshot eyes.)

A crescent of gold-lip mother-of-pearl shell frames the jaw of another Chimbu from the Mount Wilhelm area (pages 80–81), and quills from a cassowary's wing feathers are stuck through his pierced nasal septum, along with a shell disk.

Pages 82, 83: Two men from the Sinasina area, Chimbu Province.

Their faces are daubed with different colored clays, applied in paste form. As the clay dries, it cracks and flakes off. The first man (page 82) wears tiny dried fern leaves in the sides of his nostrils.

Pages 84–88: Five men from the Lufa area, Eastern Highlands Province.

They are decorated in typical fashion with moss and grass, with boars' tusks or clumps of grass passed through their noses. One man (page 88) peers through a mask framed by chicken feathers and leaves and decorated with real teeth. Andrew Strathern points out that in the Eastern Highlands masks are sometimes worn in small ceremonial plays or farces that are designed to amuse and instruct.

Page 89: A man, probably from the Okapa area, Eastern Highlands Province.

A heavy coating of gray and orange clay covers his face and has been built up over his nose into an exaggerated ridge, producing a masklike effect.

Pages 90–93 : Three men and a woman (page 93) from the Asaro/Watabung area, Eastern Highlands Province.

Their faces are covered with heavy coats of flaking clay. The woman is a widow in mourning, and she wears headgear made of gray grass seeds, *Coix lachryma*, or Job's tears, which are commonly used throughout the Highlands in the making of mourning decorations.

Page 94: A man from the Chuave area, Chimbu Province.

He is evidently imitating the decoration popularized by the so-called mud-men from the Asaro River region. His clay helmet is inset with bamboo horns, and his fingers are accentuated by pointed bamboo tubes. His necklaces are made from boars' tusks and empty seedpods.

Page 95: A "mud-man" from the Asaro River area, Eastern Highlands Province.

He is caked with clay from head to foot and wears a clay helmet molded over a cane- and bark-cloth framework. It has been suggested that as the clay cracks and peels off, it symbolizes the flesh of a decaying corpse. The man holds a bunch of leaves, which he uses from time to time to flick away imaginary flies that are settling on his "rotting" flesh.

Page 96: A Benabena man from Eastern Highlands Province.

He wears a marsupial-fur headband, and a pair of boars' tusks through his septum. His lips are stained red from chewing betel nut mixed with lime.

Page 97: A man, possibly from the Tambul area, Western Highlands Province.

His headband is made from nassarius shells backed with bark cloth. A pale blue occipital plume from the adult male King of Saxony Bird of Paradise frames his chin. His face is blackened, making him difficult to recognize, which is considered an important aspect of self-decoration.

Pages 98, 99: A Benabena man and woman (page 99), Eastern Highlands Province.

Both wear head coverings of the light gray grass seeds known as *Coix lachryma*, or Job's tears. Their faces are blackened with charcoal, which in the man's case has been mixed with pig fat to add a sheen.

Page 100: An Okapa man from Eastern Highlands Province.

Although he himself is from Okapa, the design he wears has been copied from that worn in the Goroka area. His green scarab-beetle headband is topped with a row of white buttons, a modern-day substitute for the traditional nassarius shells.

Page 101: A Roro tribesman from Central Province.

He has the elegant bone structure typical of Papuans living along the south coast. His headdress, not visible here, is surprisingly similar to that worn by the Torres Straits islanders, the Samo (see page 102) and their neighbors in the Western Province, and even by the Huli in the Southern Highlands for their *dawe bilagu* ceremony.

Pages 102, 103: A Samo man from the Nomad River area, Western Province.

This decoration is worn by the chief dancer in the *hobora* ceremony, in which a previously initiated man demonstrates his powers to cure the sick.

His face is circled by a halo of white cockatoo feathers and a slender *kina*-shell crescent. His nose plug is of hollow cassowary bone, and his headband consists of a double row of dogs' teeth above which is possum fur and the russet flank plumage of the Raggiana Bird of Paradise. He wears a shell necklace, and loops of gray grass seeds dangle from his ears. His shoulders, chest, and knees are carefully painted with natural earth colors in what seems to be a skeletal design. However, Andrew Strathern believes the design might be imitative of the markings on a snake, which, through its ability to shed its skin, symbolizes rejuvenation. Tufts of shredded palm leaves and a cassowary-bone dagger are pushed through his finely woven armbands. Invisible here, a crayfish claw rattle and an ankle-length tail consisting of a spray of shredded black-palm leaves are tucked into his bark belt, and the plumage of another Raggiana arches up behind his shoulders.

There is a marked resemblance both in his physical appearance and in his dance to the male Raggiana Bird of Paradise. Rhythmically pounding his drum, he hops and bows in tight circles, causing his tail to fluff out like the excited bird during its courtship display. The views of two other individuals who have watched the ceremony—Dr. Clemens Voorhoeve, a linguist, and Dr. Daniel Shaw, an anthropologist at the Summer Institute of Linguistics—partly support this. Voorhoeve, in a personal communication, writes: "I think the dancer imitates the male bird-of-paradise, and the whole performance has strong allusions to mating/love-making. During a performance I watched in Sokabi village, the dancer at one stage circled a girl crouched on the floor. Perhaps she represented the female bird; maybe she was sick, as an informant later told me, and was 'cured' in this way. I think it very well possible that a ceremony like this has many facets: the vitality it expresses of the grown-up boy attaining manhood could easily be seen as having a curative effect on those who are weak or ill."

Daniel Shaw emphatically states that the ceremony makes no allusion to mating, and that the girl observed by Voorhoeve does not represent a female bird. She is simply being cured by the dancer, who, as an initiate, possesses supernatural powers to heal and protect. He adds: "This imagery derives from Samo aesthetics which considers the Raggiana Bird-of-Paradise (*Paradisaea raggiana*) the most beautiful creature in the forest. Though, like man, the bird is not strong, it inspires awe and respect when in [courtship] display. Hunters recount stories of being mesmerized and unable to shoot as they watch the creatures. Just so, the dancers with their elaborate decoration command awe and respect from those human or supernatural beings who view the spectacle."

Identified below are the individuals in each photograph. The name, if known, appears in italics.

Pages 42, 43: Southern Highlands Province, Huli tribe, Kikita village, *Pulupe*, male.

Page 44: Southern Highlands Province, Huli tribe, Henganda village, *Harinda*, male.

Page 45: Southern Highlands Province, Huli tribe, Pai village, *D'yari*, male.

Page 46: Southern Highlands Province, Huli tribe, Karida village, *Nabe*, male.

Page 47: Southern Highlands Province, Huli tribe, Paipali village, *Tomyepe*, male.

Pages 48, 49: Southern Highlands Province, Huli tribe, Piribu village, *Mokai*, male.

Page 50: Southern Highlands Province, Huli tribe, Hiwanda village, *Badyebe*, male.

Page 51: Southern Highlands Province, Huli tribe, Ialuba area, *Embedame*, female.

Pages 52, 53: Southern Highlands Province, Huli tribe, Ialuba area, *Huliya*, male.

Page 54: Southern Highlands Province, Huli tribe, Kikita village, *Tidyebe*, male.

Page 55: Southern Highlands Province, Huli tribe, Halimbu village, *Arugya*, male.

Pages 56, 57: Southern Highlands Province, Mendi area, Tente village, *Kongel*, male.

CAPTIONS : MASKS

Page 105: A masked figure stands before the spirit house at Palimbei village on the Sepik River.

Page 106: Eastern Torres Straits: turtle-shell mask. Height: 47 cm. Australian Museum, Sydney, Australia (E-10403).

Page 107: Torres Straits: turtle-shell mask. Height: 60 cm. Private collection, Europe.

Pages 108, 109: Torres Straits, Saibai Island: wood *mawa* mask. Height: 56 cm. Otago Museum, Dunedin, New Zealand (D-20.482).

Pages 110, 111: Torres Straits: wood *mawa* mask. Height: 59 cm. The Royal Pavilion, Art Gallery and Museums, Brighton, England (Aa-103).

Page 112: Middle Sepik River, Boiken linguistic group: wood mask. Height: 43 cm. Collection Alain Schoffel, Paris, France.

Page 113: Ramu River, Sogeram tributary: wood mask. Height: 55 cm. Private collection, Paris, France.

Page 114: Middle Sepik River, Boiken linguistic group: wood mask. Height 35 cm. Private collection, New York, United States.

Page 115: Lower Sepik River, wood mask. Height: 34.5 cm. Private collection, Brussels, Belgium.

Pages 116, 117: Astrolabe Bay: wood mask. Height 42 cm. Private collection, United States.

Page 118: Huon Gulf, Tami Island: wood mask. Height: 46 cm. Private collection, United States.

Page 119: Astrolabe Bay: wood mask. Height: 69 cm. Museum für Völkerkunde, Basel, Switzerland (vb-18104).

Page 120: Sepik River: overmodeled human skull. Height: 15 cm. Private collection, United States.

Page 121: New Britain, Sulka tribe: pith mask belonging to a secret society. Height: 120 cm. Übersee Museum, Bremen, West Germany (D-13679).

Page 122: New Britain, Gazelle Peninsula: overmodeled human skull. Height: 22.5 cm. Private collection, Brussels, Belgium.

Page 123: New Britain, Gazelle Peninsula: overmodeled human skull. Height: 26 cm. Collection Charles Ratton, Paris, France.

Pages 124, 125: New Ireland: wood *tatanua* mask. Height: 16 cm. Collection Alain Schoffel, Paris, France.

Page 126: New Ireland: wood *tatanua* mask. Height 38 cm. Collection Charles Ratton, Paris, France.

Page 127: New Ireland, Tabar Island: hollow wood mask. Height: 56 cm. Collection Ben Heller, Inc., New York, United States.

Pages 128, 129: New Ireland: wood *malanggan* mask. Height: 70 cm. Collection Charles Ratton, Paris, France.

Page 130: New Ireland: wood *matua* mask. Height: 151.5 cm. Rautenstrauch Joest Museums für

Völkerkunde, Cologne, West Germany (Köln-40075).

Page 131: New Ireland, Tabar Island: wood head. Height: 20 cm. Private collection, France.

Pages 132, 133: New Ireland, Tabar Island: wood mask. Height 61.5 cm. Private collection, France.

Page 134: New Ireland, Tabar Island: hollow wood mask. Height: 58 cm. Private collection, France.

Page 135: New Ireland, Tabar Island: hollow wood mask. Height: 45 cm. Collection Baudouin de Grunne, Brussels, Belgium.